IMAGES
of America

MILWAUKEE'S
SOLDIERS HOME

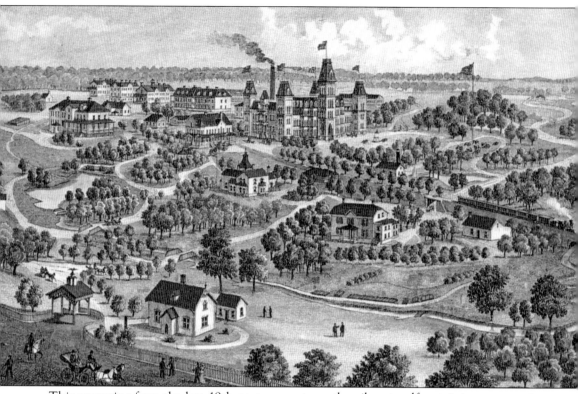

This engraving from the late 19th century captures the vibrant, self-sustaining community of the Northwestern Branch, National Home for Disabled Volunteer Soldiers, in Milwaukee, Wisconsin. A locomotive of the Chicago, Milwaukee & St. Paul Railway chugs through the rolling landscape of lakes, streams, farmlands, formal gardens, and stately Victorian buildings. (Engraving by the Milwaukee Lithography & Engraving Company, courtesy of the Clement J. Zablocki VA Medical Center.)

On the Cover: World War I veterans gather in a connecting hallway of the newly opened tuberculosis hospital (Building 70) of the Northwestern Branch, National Home for Disabled Volunteer Soldiers, around 1924. The design and special features of the facility were the result of a national effort after World War I to care for veterans suffering from this contagious disease. (Courtesy of the Clement J. Zablocki VA Medical Center.)

IMAGES of America
MILWAUKEE'S SOLDIERS HOME

Patricia A. Lynch

ARCADIA
PUBLISHING

Copyright © 2013 by Patricia A. Lynch
ISBN 978-0-7385-9873-4

Published by Arcadia Publishing
Charleston, South Carolina

Printed in the United States of America

Library of Congress Control Number: 2012950196

For all general information, please contact Arcadia Publishing:
Telephone 843-853-2070
Fax 843-853-0044
E-mail sales@arcadiapublishing.com
For customer service and orders:
Toll-Free 1-888-313-2665

Visit us on the Internet at www.arcadiapublishing.com

Dedicated to our nation's veterans and to those who have helped them bear the battle, including Fanny Burling Buttrick, Lydia Ely Hewitt, Hannah Vedder, and the Lady Managers of the first Milwaukee Soldiers' Home, from 1864 to 1867

Contents

Acknowledgments		6
Introduction		7
1.	The Northwestern Branch	11
2.	The "Old Soldiers"	19
3.	The Home as Tourist Attraction	31
4.	The Veteran Population Boom	43
5.	The Officers, Staff, and Families	59
6.	The Neighborhood and Neighbors	75
7.	The Years After the Great War	87
8.	A New Era of Veteran Care	99
Bibliography		127

Acknowledgments

This book would not have been possible without the passion, curiosity, and hard work of several employees of the Clement J. Zablocki Veterans Affairs Medical Center (VA). In 2002, Laura Rinaldi, who for years had given tours of the historic district as part of the VA's new-employee orientation, created Reclaiming Our Heritage, an annual living-history and veteran-tribute event held the weekend following Memorial Day. The purposes of the annual event include calling attention to the architectural splendor of this historic campus (now barely visible behind the retractable roof of the newly completed Miller Park baseball stadium) and reintroducing the public to a significant but forgotten chapter in American social history. Efforts by fellow VA employees, veterans, and members of the community at large have shaped this event into an attraction for tens of thousands of visitors.

Reclaiming Our Heritage volunteers inspired a rebirth of the West Side Soldiers Aid Society, the organization that originally established the first state soldiers' home in downtown Milwaukee. The modern-day West Side Soldiers Aid Society has wholeheartedly supported this project and other efforts to highlight VA history.

VA librarians Jill Zahn and Janice Curnes have been sources of inspiration in their knowledge of VA history and guidance in locating photographs for this book. Curnes, Rinaldi, and Zahn also were proofreaders, along with Veterans Health Administration historian Darlene Richardson and West Side Soldiers Aid Society member Aaron Skinner.

Thanks are due Karen and Ron Hayward, West Milwaukee Historical Society, and others who allowed the publication of their images, and to Ellen L. Puerzer, whose careful transcription of *Milwaukee Sentinel* articles helped clarify many historical details.

The West Side Soldiers Aid Society gratefully acknowledges the support of our publishing partners: the Civil War Round Table of Milwaukee, the Prairieville Irregulars, Patricia J. Adams, Ellen DeMers, Mary Agnes Kuehmichel, Clarence Kuehmichel, Patrick Lynch, Jennifer Risley, Jean Schwonek, and Sharon Wildes, and the guidance of our Arcadia Publishing acquisitions editors, Winnie Rogers Timmons and Katie Toussaint. I am indebted to the patience and encouragement of my husband, Patrick Lynch, and his mother, Jane Lynch, who have been my ever-faithful advisors.

The images in this volume appear courtesy of the Clement J. Zablocki VA Medical Center, Milwaukee, Wisconsin, except as noted.

Introduction

With malice toward none; with charity for all; with firmness in the right, as God gives us to see the right, let us strive on to finish the work we are in; to bind up the nation's wounds; to care for him who shall have borne the battle, and for his widow, and his orphan.

—Pres. Abraham Lincoln

By the time our 16th president uttered these powerful words in his second inaugural address on March 4, 1865, the citizens of Wisconsin had already placed them into action. On March 3, the day before giving this speech, President Lincoln signed legislation to create a permanent national home for volunteer Union soldiers, the first hospitalization and long-term-care facility for US volunteer soldiers in our nation's history. In the first two years of the Civil War, the women of Milwaukee's West Side Soldiers' Aid Society supported the United States Sanitary Commission in providing relief for Union soldiers. In early 1864, witnessing growing numbers of disabled and destitute soldiers arriving in Milwaukee, they rented rooms on West Water Street (now North Plankinton Avenue), offering shelter, clothing, food, and medical care to any soldier in need. Just days after their grand opening, the women used the *Milwaukee Daily Sentinel* to state their case:

> When the contest for right is over and the thousands of sturdy sons of Wisconsin return from the havoc of battle, maimed, crippled and helpless for life, a home of magnificent proportions, for which we have not marble white enough, must be built. This temporary resting place may prove the cornerstone of a permanent home for our battle-scarred heroes for all time to come.

In early 1865, the women garnered the support of Gov. James T. Lewis and the Wisconsin State Legislature, receiving a charter as the Wisconsin Soldiers' Home Association, a $5,000 appropriation, and permission to begin fundraising.

At a successful Soldiers' Home Fair held in June and July 1865, the Wisconsin Soldiers' Home Association entertained the returning "boys in blue" and raised over $100,000 to purchase land and hire an architect. Before construction began, however, the Lady Managers were persuaded to divert their assets to a greater cause: the establishment of a National Asylum for Disabled Volunteer Soldiers in Milwaukee. The lobbying efforts of George Walker, Erastus B. Wolcott, and Matthew Keenan bore fruit in the selection of Milwaukee as the Northwestern Branch. The Eastern Branch, at Togus, Maine, opened its doors in the fall of 1866, followed shortly afterwards, in 1867, by the Northwestern Branch in Milwaukee and the Central Branch in Dayton, Ohio. The Lady Managers always contended:

> This home is not a wayside charity, or a transient recreation, but a serious and permanent assumption of a sacred duty which we owe the defenders of our common country. It is food for the hungry, comfort for the cheerless, sympathy for the afflicted. It is a constant acknowledgment that we too have duties . . . which can neither be postponed nor evaded. It is an embodied declaration that we at home acknowledge our obligations and are willing to share with [our heroes] the arduous responsibilities of the hour.

When planning the needs of the National Asylum, its managers followed the same philosophy, stating that they would provide subsistence, quarters, clothing, religious instruction, employment when possible, and amusements to volunteer soldiers. These benefits would be forfeited "only by bad conduct at the home, or conviction of heinous crimes." An 1889 article in the *Milwaukee Sunday Telegraph* assures prospective residents that "the Home," as it was then called, is "a place where good behavior insures the kindest treatment."

Located in the scenic countryside on the western fringes of Milwaukee, the Northwestern Branch was established on land owned by prominent citizens, including John Lendrum Mitchell, father of pioneer military aviator William "Billy" Mitchell. Local manager Dr. Erastus B. Wolcott, architects Edward Townsend Mix and Henry C. Koch, and landscape architect Chaplain Thomas Budd Van Horne were involved in the development of the buildings, grounds, and cemetery.

As Milwaukee's Soldiers Home evolved, so did the surrounding communities. As anticipated by the lobbyists who pressed for locating the Northwestern Branch in Milwaukee, businesses in Milwaukee, West Milwaukee, West Allis, and Wauwatosa experienced a boost from supplying the needs of the Home. Architects, contractors, and members of the building trades were called into service during several phases of construction. Local brewers, including Philip Best Brewing Company, Miller Brewing Company, and Joseph Schlitz Brewing Company, supplied the Home with refreshment. A tavern culture flourished along National Avenue and Spring Street, as well as in surrounding neighborhoods. The beauty and amenities of Milwaukee's National Home attracted tens of thousands of tourists each year. Boating, fishing, outdoor concerts, and carefully landscaped gardens were just a trolley ride away for local residents and a day's ride by rail for excursions from other parts of the state. Wisconsin citizens wanted to see firsthand what their contributions had made possible and to honor the defenders of the Union.

In January 1873, the National Board of Managers changed the name of the institution to the National *Home* for Disabled Volunteer Soldiers (NHDVS) and commissioned an emblem and badge to be worn by members and staff. On the emblem, Lady Columbia, representing a grateful nation, presents a chalice—the gift of the National Home—to a disabled soldier, an amputee. The bounty of the harvest rests at his feet, a sign that the nation will provide for his every want. Stacked muskets, silent cannons, and crossed swords symbolize the end of hostilities, and a laurel wreath recalls the victors of battle, including those who did not return home. Under the banner bearing the name of the National Home is a simple phrase: The Nation to Her Defenders. The date on the badge—March 3, 1865—marks the signing of the National Asylum legislation by President Lincoln.

Although far removed from the battlefield, veterans living at the National Home continued to fight their battles with chronic illnesses, disfiguring injuries, and what we now know as posttraumatic stress. Discipline and military order were important components of a strict daily routine consisting of inspections and work details balanced with ample opportunities for recreation and amusement. The controlled environment provided structure and protective boundaries for veterans, but those boundaries were often breached by soldiers taking a trip to a local saloon, going absent without leave, or perpetrating an offense against the order and discipline of the Home.

During the 1880s, an aging veteran population, with many members suffering from dementia, drove the need for innovations in health care and additional construction, including a new hospital, administrative building, recreation hall, chapel, library, multipurpose hall, and smaller, single-purpose buildings in the area surrounding the main building.

Heavy industry moved into the area during the late 19th century, forming an industrial corridor along the Menomonee River Valley from Milwaukee to West Allis. In addition to nearby breweries, factories such as the Allis-Chalmers Manufacturing Company and the Pawling & Harnischfeger Machine and Pattern Shop contributed to building projects at the National Home. When the Wisconsin State Fair moved to its present location in West Allis in 1892, the early trolley lines, which previously ended at the National Home, were extended to the fairgrounds.

Following the Great War, now known as World War I, the country scrambled to adapt or build facilities for a new generation of veterans affected by modern warfare, which at the time included

mustard gas. The Northwestern Branch, once on the verge of being closed as the number of Civil War veterans dwindled, found renewed purpose with the construction of a new veterans' tuberculosis hospital. In 1930, Pres. Herbert Hoover issued an executive order to "consolidate and coordinate Government activities affecting war veterans." The Bureau of Pensions, the United States Veterans' Bureau, and the National Home for Disabled Volunteer Soldiers were placed under one umbrella federal entity, the newly created Veterans Administration, under direction of Brig. Gen. Frank T. Hines from the Veterans Bureau. Under the Veterans Administration, a hospital annex was constructed at Milwaukee and upgrades and additions were made to many existing buildings. In the 1940s, World War II brought more unique challenges in veterans' care, prompting plans for a new facility with state-of-the-art treatment and rehabilitation options.

In 1928, an unused portion of the National Home land was transferred by the federal government to the City of Milwaukee. That parcel was later used as the site for Milwaukee County Stadium and its first resident team, the Milwaukee Braves. The Soldiers' Home Reef, a fossil-laden formation from the Silurian age, discovered in the 1830s by Increase A. Lapham, is the dividing line between the present-day Clement J. Zablocki VA Medical Center and Miller Park (the ballpark that replaced Milwaukee County Stadium in 2001). The reef was designated as a National Historic Landmark by the US Department of the Interior on November 4, 1993.

The Home has had several names since its opening in 1867. It was originally called the Northwestern Branch, National Asylum for Disabled Volunteer Soldiers, with *Asylum* being changed to *Home* by act of Congress in 1873. Col. Charles M. Pearsall authorized the new post office address of Wood, Wisconsin, in 1937, in honor of Gen. George H. Wood, longtime president of the National Board of Managers. Even today, veterans and visitors refer to the campus simply as Wood or Woods. Following the death of US congressman and veteran advocate Clement J. Zablocki, Pres. Ronald Reagan renamed the medical center in his honor on October 19, 1984. Today, the campus proudly bears the honorary name of Clement J. Zablocki Veterans Affairs Medical Center, Milwaukee, Wisconsin.

Likewise, the cemetery has evolved in size, name, and management. Originally known as the Soldiers' Home Cemetery, it was the final resting place for National Home residents, called "members," and some of the staff. In 1937, it was renamed Wood Cemetery in honor of General Wood, and burial was opened to any eligible veteran, including those who had not lived at the Home. In 1973, management was transferred to the National Cemetery Administration, and it became Wood National Cemetery. It has been the heart of Milwaukee's Memorial Day commemorations since 1871 and a constant visual reminder, with its rows and rows of perfectly aligned white headstones, of the sacrifices made in every US war and military conflict after the Revolutionary War.

The Ward Theater was listed in the National Register of Historic Places in 1984, and the district as a whole was added in 2005. On June 17, 2011, the Northwestern Branch was designated a National Historic Landmark, along with the Western Branch, Leavenworth, Kansas; Battle Mountain Sanitarium, Hot Springs, South Dakota; and the Mountain Branch, Johnson City, Tennessee. In 2012, the Central Branch at Dayton, Ohio, was also designated a National Historic Landmark.

The purpose of this book is to celebrate the long and continuing legacy of federal veterans' health care in Milwaukee while at the same time honoring some of the men and women who lived and worked at the Northwestern Branch. While every effort has been made to identify photographs and to give accurate and meaningful descriptions, new details are still emerging in primary sources. Sometimes, these details answer questions and solve mysteries, and sometimes they challenge long-held beliefs. This National Historic Landmark has many more secrets to share, stories to tell, and mysteries to be solved.

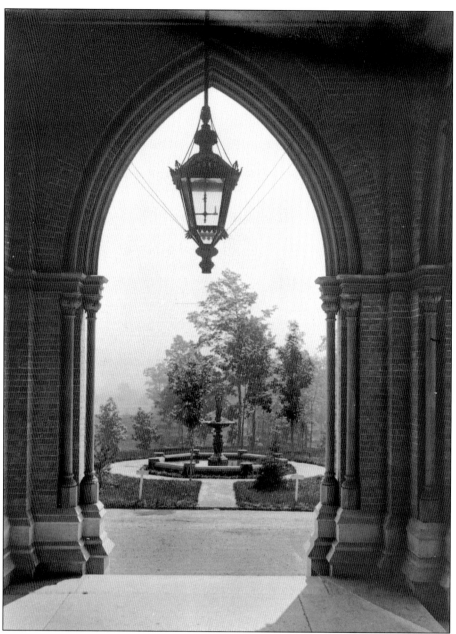

The central location and elevation of the main building were matched by its scale and stately Victorian architecture. Not only did this building serve the Civil War veterans who first walked through its doors in 1869, it also made a bold statement: This is how a grateful nation attempts to repay a debt owed to the defenders of the Union. The view from the grand entrance, framed in this photograph by the arches and ornate lamp of the landing, looks across Central Avenue toward the fountain, rolling lawns, and, in the distance, the outskirts of 1880s Milwaukee. On May 19, 1887, Henry Hamilton Bennett, a Civil War veteran and renowned Wisconsin photographer, visited the Northwestern Branch of the National Home, capturing this scene and producing an exceptional collection of interior and exterior images. Many of Bennett's photographs of the Home were produced as stereographs. (Courtesy of Wisconsin Historical Society, WHS-7403.)

One
THE NORTHWESTERN BRANCH

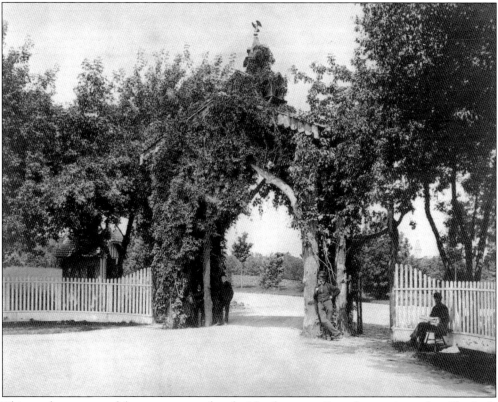

This gatehouse, one of three constructed at the Northwestern Branch, was situated on Elizabeth Street, a part of the Mukwonago Plank Road. The design of the entrance, complete with birdhouses and a hand-carved eagle, is typical of the rustic landscape features crafted by the veteran residents of the Home. In 1878, Elizabeth Street was renamed National Avenue for its proximity to the National Home. The main building is visible on the right above the picket fence.

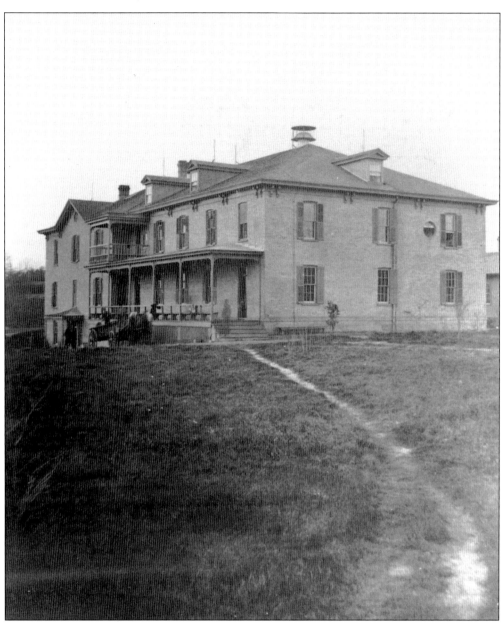

This first structure, designed as a temporary residence, was built in a matter of months and opened in fall 1867. Until its completion, the first arrivals from the downtown Wisconsin Soldiers' Home lived in smaller buildings already on the property. One of the first veterans, Hezekiah Atwood, served as a musician in the War of 1812. He enlisted in the 5th Wisconsin Volunteer Infantry during the Civil War, remaining with that regiment until being discharged for infirmity. In the first years of the National Home, admission requirements were simple: an honorable discharge from US volunteer service and disability by wounds received or sickness contracted in the line of duty. The National Homes' board of managers asked almshouses and charitable hospitals to report any soldiers in need of care. When necessary, transportation was provided by the federal government. After completion of the main building in 1869, this structure served as a hospital until construction of a new hospital facility in 1879. (Courtesy of Milwaukee County Historical Society.)

The governor's residence was built in 1868, most likely by Milwaukee architect Edward Townsend Mix. When it was modified in the 1890s, its original Italianate architectural style was transformed into the popular Queen Anne style of the period. At one time, the basement contained a vegetable storage bin, a coal bin, and a brick cistern to catch rainwater from the roof.

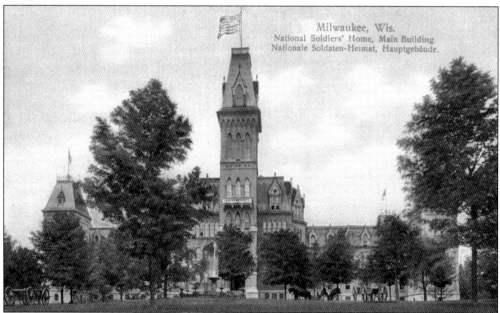

A horse-drawn carriage pulls in front of the iconic main building, which was occupied and dedicated in September 1869. Improvements were made and corner towers were added in 1875. "Old Main," as it was known, included sleeping quarters for all members of the Home, a dining room, administrative offices, library, chapel, billiard and pool room, meeting hall, laundry, bathing facilities, and medical services.

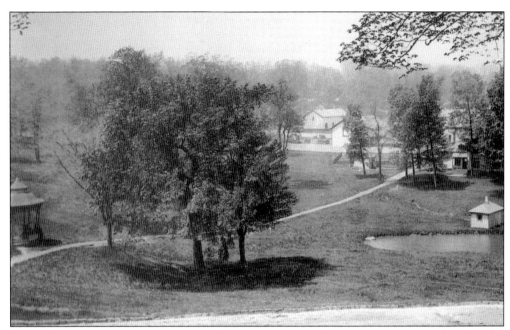

The farmhouse and barns were located on roughly 100 acres north and east of Old Main. The *Milwaukee Telegraph* reported that the 1889 harvest alone amounted to $17,000 worth of provisions, including 1,860 cabbages and 210 tons of hay. The hay, used for winter feeding of 59 head of cattle, 15 horses, and 6 mules, was stored in a 600-ton silo.

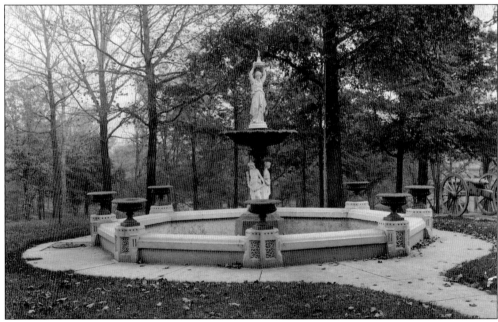

The first of many exquisite landscape features, the fountain was crafted and installed by Milwaukee artisan Casper Hennecke in 1870. Three graceful female figures surround the pedestal base of the fountain, while a solitary female figure lifts an urn above her head. Water gently splashes from the urn into the fountain base. Originally flanked by two working cannons, the fountain has been a restful spot for veterans and visitors alike.

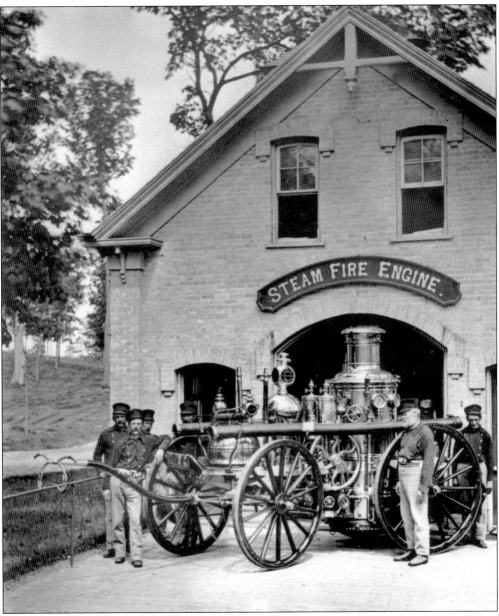

An Amoskeag Company steam fire engine was delivered to the Home in January 1870. The first fire of any note occurred on October 2, 1871, when suspected arson destroyed a barn and two stacks of hay. The fire crew and its trusty steamer, named the *George H. Walker* after the late NHDVS advocate, did their best to contain the blaze and received the compliments of the Home governor for their efficiency. A June 1, 1874, *Milwaukee Sentinel* account of Decoration Day activities includes a description of the fire company uniforms: black broadleaf hat, red shirt, and black pants. A large portion of the company, it mentions, consisted of one-armed men. The steam-engine house in this 1887 photograph was built along the railroad tracks east of the main building and adjacent to Lake Hincks. It later served as an oil house until it was demolished in 1938. A second firehouse, a two-bay engine house with living quarters, was built in 1883. (Courtesy of Wisconsin Historical Society, WHS-9220.)

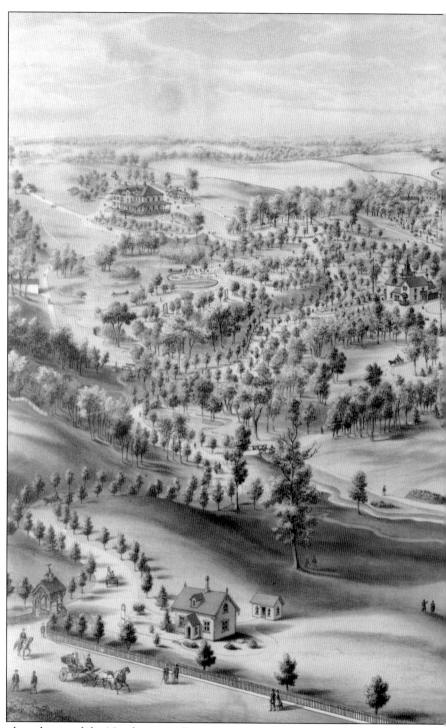

This detailed aerial rendering of the Northwestern Branch was executed sometime before 1875 by the American Oleographic Company of Milwaukee. The rustic Elizabeth Street entrance and gatehouse are located at the lower left corner of the image, and the Spring Street gatehouse is at the upper right. Features from this early era of the Home include a flagpole shaped like a ship's

16

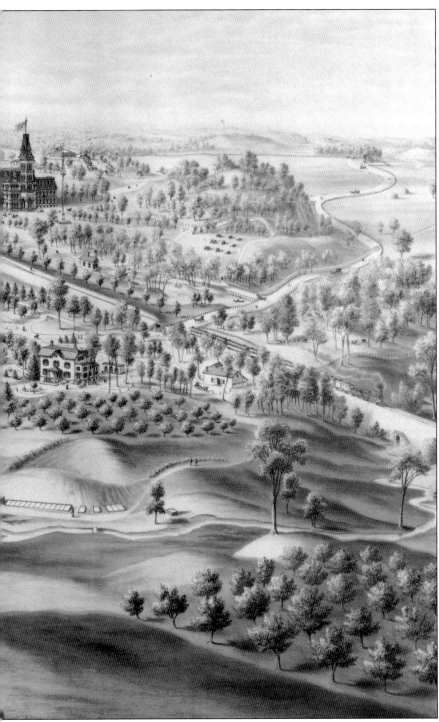

mast, an artillery field, carefully landscaped grounds and gardens, waterways, and lakes (including a lake for harvesting ice). The artist's key notes that the mineral spring on the center-left side of the print flowed at the rate of 4,780 gallons per hour.

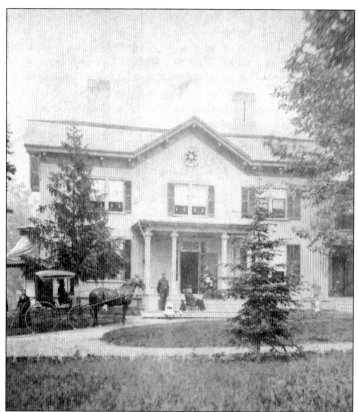

Mote Brothers of Richmond, Indiana, captured this scene in front one of the earliest residences constructed specifically for staff. According to notes on the back of the image, Capt. W.H. Lough, secretary, and Dr. John L. Paige, surgeon, lived in this duplex during the administration of Gov. Edward W. Hincks. Paige was chief surgeon from 1876 to 1878. The residence was demolished in 1986.

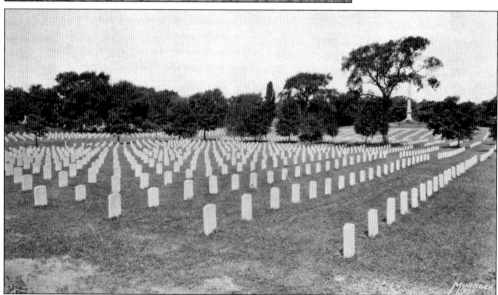

In the early years of the Home, members were buried at Calvary Cemetery, the adjacent Catholic cemetery, or Forest Home Cemetery. The Home cemetery, designed by Chaplain Thomas Budd Van Horne, was dedicated on June 12, 1871. Over the years, thousands of white granite headstones were added, telling, according to a 1924 souvenir book, the "history of him who, in slumber beneath, awaits the eternal 'Reveille.' "

Two
THE "OLD SOLDIERS"

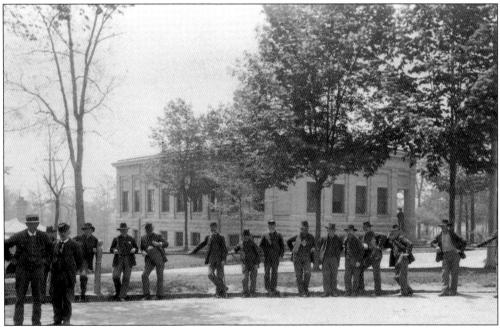

Each veteran admitted to the Home was assigned to a company according to his type of disability. Free clothing included a blouse, vest, trousers, shoes, wool shirts, canton flannel drawers, cap, and overcoat. In 1889, the *Milwaukee Telegraph* noted that clothing was standard military issue, but of what one officer touted as better quality, with polished brass buttons. (Courtesy of Milwaukee Public Library, Milwaukee Historic Photos Collection.)

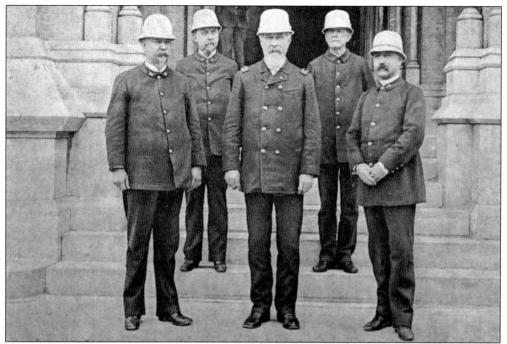

Each Home company was commanded by a sergeant and a corporal. The governor served in the same capacity and style as the commander of a military post, exercising control over the grounds, buildings, furniture, vehicles, stock, and staff. Gen. Jacob Sharpe (center) served as governor from 1880 to 1889, and Kilburn Knox (far left) served as secretary. Knox succeeded Sharpe as governor in 1889.

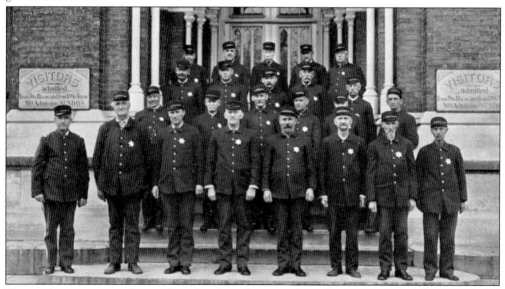

The need to maintain order and discipline kept these guards on the alert in 1916. Offenses included leaving the grounds without a pass, disorderly conduct, drunkenness, and refusing to take a bath. Court was held every morning, with the guilty paying a fine, accepting assigned labor, or being jailed in one of the six guardhouses. The provost sergeant kept 50 remodeled Enfield rifles ready for immediate use.

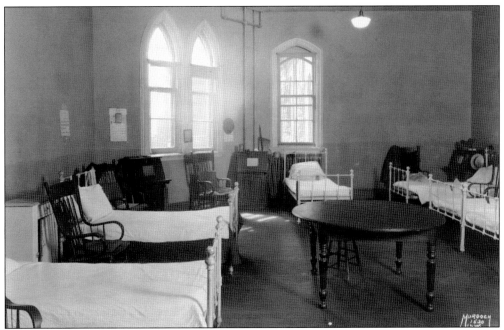

Accommodations for each resident in Old Main and later barracks included an iron bedstead with woven iron springs, a wool mattress, four blankets, sheets, pillowcases, armchair, and wardrobe. Barrack rules dated March 10, 1924, emphasized that members should place papers under their shoes when lying on the beds. This dormitory in Ward Three of the main building was photographed in the 1920s by James Blair Murdoch, a local commercial photographer.

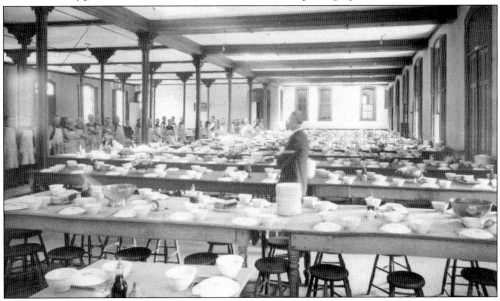

Following an 1888 dining hall addition in the main building, seating could accommodate 1,000 members. Each resident was required to occupy his assigned seat at one of the long tables during every meal of his stay at the Home. Meals were wholesome and hearty, with two kinds of meat for dinner; fish on Fridays; and ample amounts of bread, soup, vegetables, butter, coffee, tea, milk, and fruit.

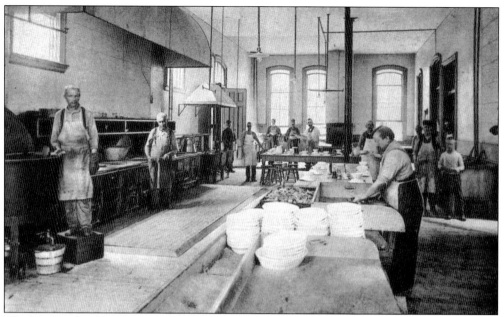

The bustling kitchen in the main building offered members one of many options for regular work duty. Members helped prepare massive quantities of food in the scrupulously clean facility. Vegetables, fruits, soups, and coffee were cooked by steam. In 1889, veterans who worked in the kitchen and dining room received $5 per month during their first year, with a $1-a-year raise for each year of continuous service in the dining room.

The Home's firefighters included civilian employees in the engineering department and Home members. They played a crucial role in ensuring the safety of members and staff, especially with some of the old-soldier hijinks and hazards of 19th-century life. Discipline records reveal one example in which a disgruntled resident stuffed another member's shoes with newspaper and set them on fire.

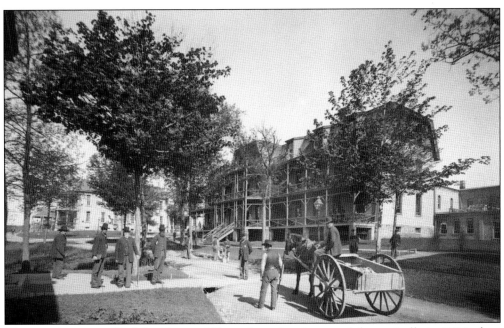

The population at all of the National Home branches increased dramatically in 1884 when Congress allowed the admission of veterans who were disabled by old age or disease. These photographs featured in the Home's 1894 souvenir book give a glimpse of the new buildings west of Old Main, including an additional domiciliary building, pictured above. Below, the general hospital (also known as Building 6), was constructed in 1879, serving patients with conditions that included tuberculosis, pneumonia, epilepsy, and general debility. In both photographs, members linger along the avenue while others engage in light work, either carrying supplies or tending the street. This kind of employment was intended to impart dignity to Home members while, at the same time, contributing to the welfare of the institution. (Courtesy of Milwaukee Public Library, Milwaukee Historic Photos Collection.)

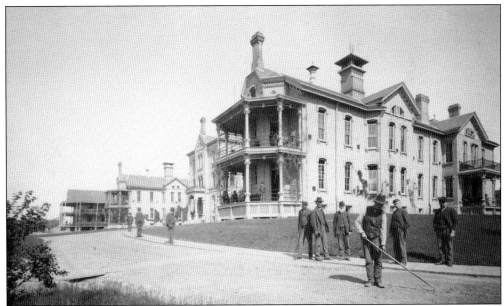

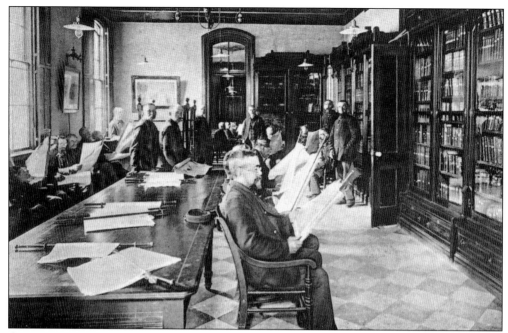

On May 19, 1869, the editor of the *Milwaukee Sentinel* issued an appeal on behalf of the chaplain, the staff member responsible for the library, requesting "flowers for the graves of those who died for us; books for those who were crippled for us." In this photograph from the 1880s, veterans read newspapers and select books from 10 large walnut bookcases constructed for the main building by Matthew Brothers Furniture Company.

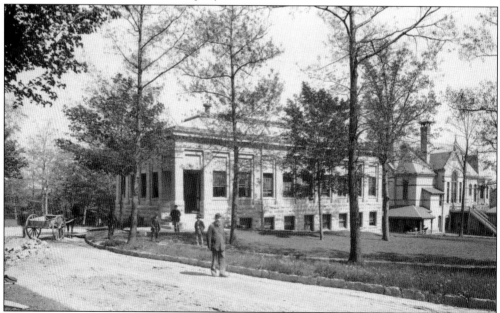

The Wadsworth Library, erected in 1891, gave all members of the Home free access to a reading room furnished with 185 of the leading magazines and newspapers in all languages. By 1924, the library boasted 12,000 volumes of the best literature, including history, fiction, science, biography, theology, and reference books.

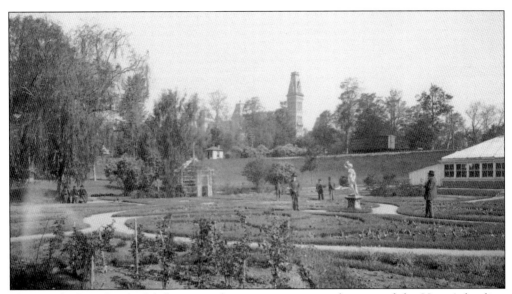

Planting beds and colorful flower gardens were important features of the Home's healing environment. Landscape architect Chaplain Thomas Budd Van Horne carefully balanced formal gardens and manicured lawns with the surrounding wilderness, setting off the buildings and other man-made features to their best visual advantage. In this 1890 photograph, the goddess *Flora* reigns over one of the formal gardens. (Courtesy of Courtesy of Milwaukee Public Library, Milwaukee Historic Photos Collection.)

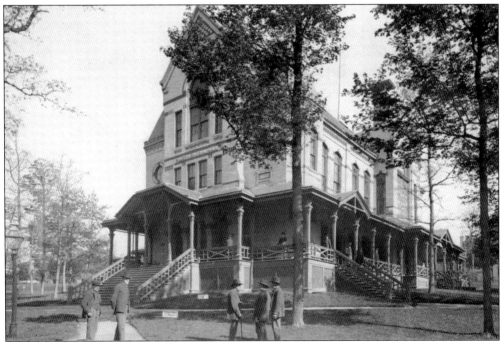

The Ward Theater provided entertainment and educational lectures. It also served as a worship space until the Home chapel was opened in 1889. Playbills affixed to the walls of a second-floor storage area reveal some of the dramatic and musical productions staged by traveling companies in the 1880s and 1890s. (Courtesy of Milwaukee Public Library, Milwaukee Historic Photos Collection.)

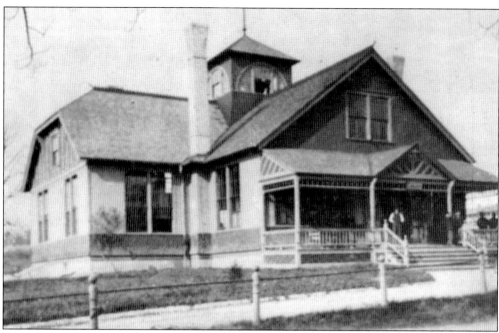

Above, the 1888 beer hall was constructed in the shape of a Greek cross, with high, arched ceilings. A central circular bar with beer faucets and pretzel racks was staffed by four bartenders, who dispensed beer to Home members for 5¢ per pint. In 1889, Pabst Brewing Company delivered an average of 15 barrels every day. Elizabeth Corbett, daughter of the Home treasurer, grew up on the grounds, 1891–1915. In *Out at the Soldiers' Home: A Memory Book*, she observed that many old soldiers led a solitary existence, even when they wandered together in great numbers, as pictured below. In the beer hall, however, they "hobnobbed with one another . . . and they never hobnobbed anywhere else." All activities at the hall were under the watchful eye of "a sober and discreet sergeant." Beer halls were abolished at all National Homes in 1907.

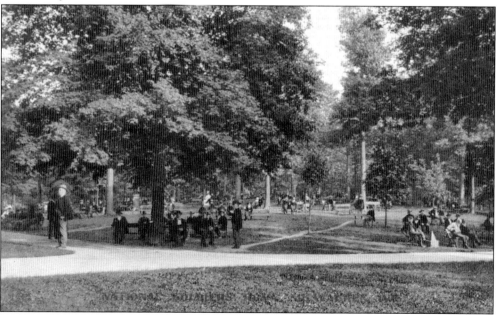

At right, a veteran of the US Colored Troops poses in front of the fountain in this postcard (postmarked July 31, 1908). Below, old soldiers assemble on the north side of the Ward Theater. The image, titled *Fighting Their Battles Over Again*, first appeared in the 1889 Home souvenir book, a popular keepsake. In addition to the typical Civil War kepis, also known as "McClellan caps," several of the veterans are wearing pith helmets, a style adopted by the US military in the 1880s for use in the Southwest. Even in their advancing years, Civil War members of the Home were known as the "boys in blue." They wore their modified Civil War uniforms until the government mandated a new khaki uniform after World War I.

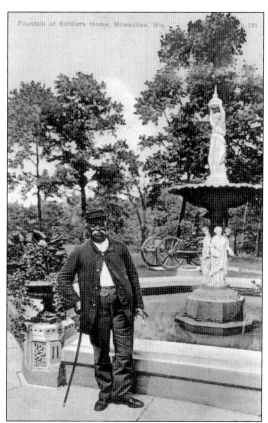

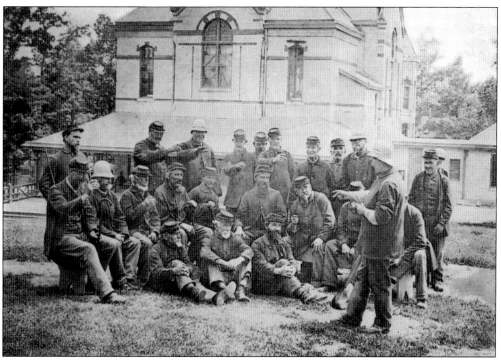

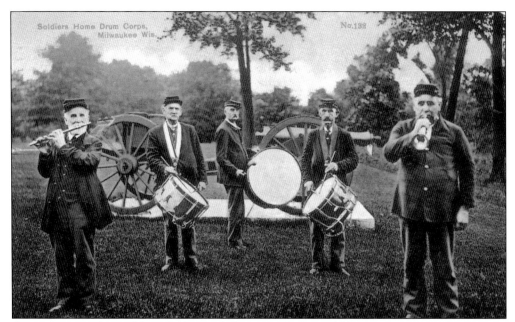

Anson Linscott (second from left) joined Company G, Second Wisconsin, at age 15, serving as drummer and medic throughout the Civil War. When he was admitted to the National Home, he joined the fife and drum corps, performing in concerts and accompanying each soldier to his final resting place in the Home cemetery.

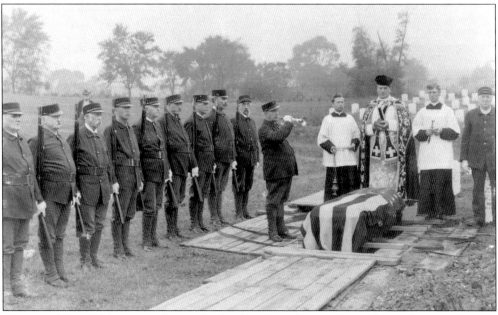

Priest, acolytes, and firing squad await the final commendation as a member of the Home sounds "Taps" in this photograph of a Catholic burial, around 1912. Improvements in the dignity of funeral services for all veterans at the Home were introduced by Chaplain Richard Ludwick in 1871. (Courtesy of Ethan Frounfelker.)

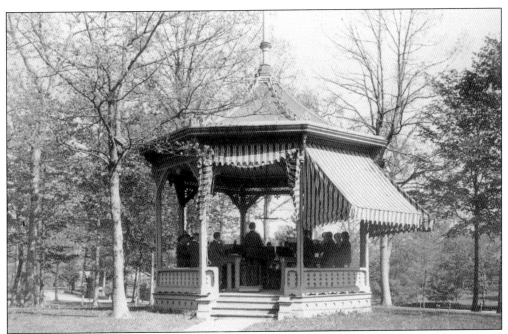

An orchestra rehearses at the music stand located in a grove south of the main building. Music, sports, other forms of recreation, lectures, religious services, and light, meaningful work gave a welcome order to the lives of many old soldiers, but there was still plenty of time to spare each day for a leisurely stroll to enjoy the natural beauty of the grounds.

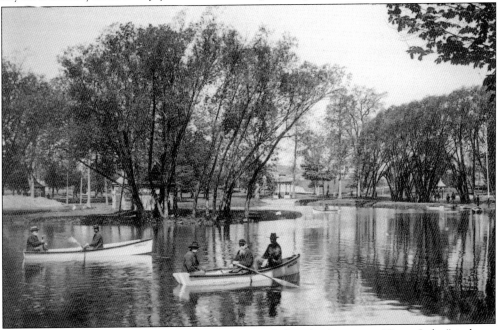

Old soldiers spend a quiet afternoon rowing on Ice Lake, also known as "Swan Lake," in boats named for Civil War heroes, including Adm. David G. Farragut, Gen. James Birdseye McPherson, Gen. Winfield Scott Hancock, and Gen. Philip Henry Sheridan. Visitors could rent rowboats for a nominal fee.

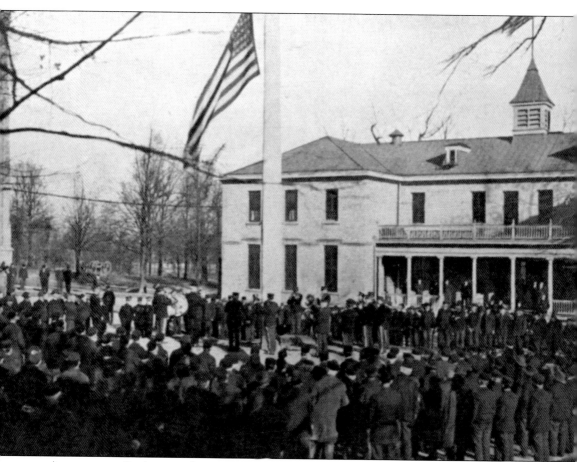

A cannon was fired twice a day: at sunrise to signal the raising of the flag and at sundown to mark its lowering. In this 1894 photograph, the band plays "Retreat" at the parade grounds south of the main building. Each day, "Reveille" was sounded at 6:30 a.m., "Tattoo" was played at 9:30 p.m., and "Taps" could be heard at 9:45 p.m. These practices continued, with or without the cannon blast, through the 1930s.

Three

THE HOME AS TOURIST ATTRACTION

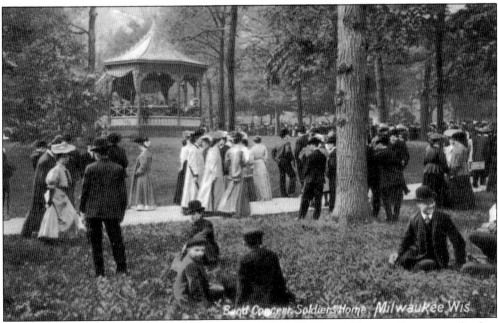

Eager to see what the government was doing for its volunteer soldiers and to enjoy the free entertainment and the natural beauty of the grounds, the public flocked to the Milwaukee Home. Patriotic celebrations and concerts attracted as many as 300,000 visitors in a single year. It was so popular that in 1916, when managers proposed closing the branch, businessman W.G. Bruce suggested converting the grounds into a public park.

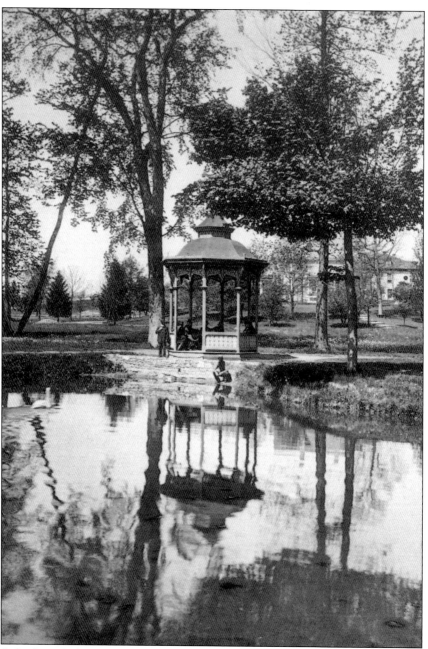

Spring Lake (later Lake Huston), Lake Hincks, Ice Lake (Swan Lake), and the farm lake were spring-fed, or "assisted," lakes. As early as 1876, Ice Lake featured a human-scale lighthouse and windmill on its small island. Two stone pedestrian bridges and a fountain were added in later years. Even though the grounds had the appearance of a park, the management of the Home posted signs at each entrance, telling all who passed through the gates that "this is not a Public Park. Visitors are expected to observe the rules of the grounds." In this 1894 photograph, veterans lounge in and around the gazebo on Ice Lake. In 1938, this lake was renamed Lake Wheeler in honor of popular Home governor Cornelius Wheeler. Lake Wheeler is the only lake remaining on the property; the other lakes either dried up or were filled in.

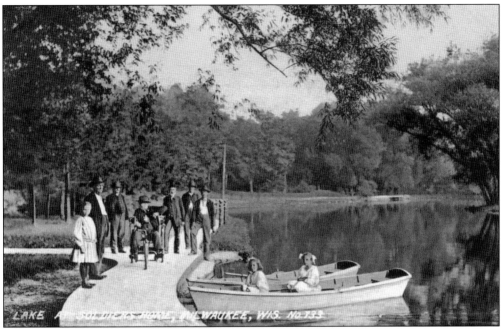

Three girls pose with a group of old soldiers, including one using a hand-cranked wheelchair. When Elizabeth Corbett chronicled the virtues and eccentricities of some Civil War veterans living at the Home, she recalled that they were always generous with Smith Brothers cough drops and other treats. The postmark on this card is 1908.

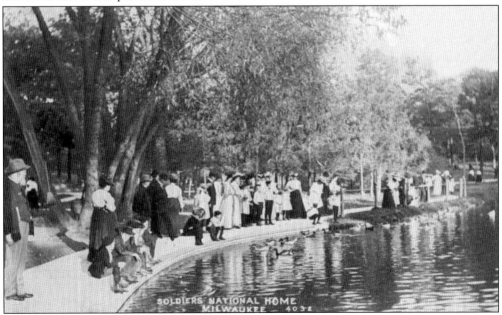

In May 1879, Gen. Edward W. Hincks posted expanded visitor regulations on signs at all the entrances to the grounds. Guidelines included prohibitions against fast driving and boisterous conduct. Hincks advised that improper characters and offenders against the rules of the Home would be ejected by the provost guard. Visitors were also reminded not to drive their teams of horses past the bandstand during performances.

Visitors to the grounds truly made themselves at home. According to Elizabeth Corbett, some picnic parties were so bold as to cross the lawns of staff residences, past the signs marked Private Grounds, to take advantage of a shady, rustic bench or even to clip a few branches from a flowering lilac bush.

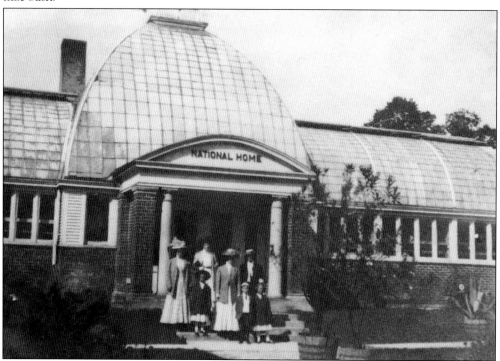

In addition to serving as a hothouse for a wide assortment of bedding plants, the conservatory provided hundreds of potted geraniums for the annual Decoration Day observances and a year-round supply of carnations and calla lilies for the hospital. On special occasions, such as veteran reunions, the old soldiers designed planting beds with the names of prominent Civil War generals and other military motifs.

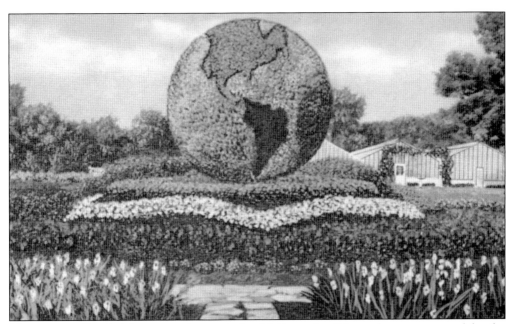

This massive floral globe, consisting entirely of foliage of striking colors, was created for the dedication of two memorial forests on October 23, 1937. The Presidential Forest and the First Ladies Forest, as well as a bird sanctuary, were funded by 44 Wisconsin camps of United Spanish War Veterans and 36 of their auxiliaries.

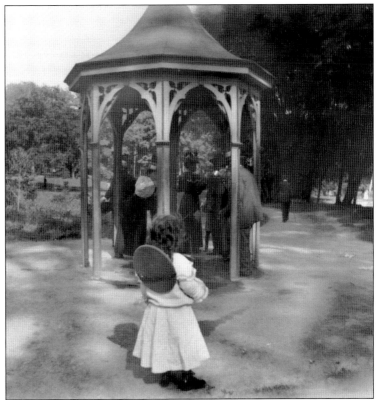

In this July 22, 1898, photograph by Harry E. Dankoler, a young girl, identified only as Syl, stands in front of Red Nose Mike, the natural mineral spring in the southwest portion of the grounds. Soldiers and visitors used small tin cups, attached to the spring by chains, to take the waters. (Courtesy of Wisconsin Historical Society, WHS-68493.)

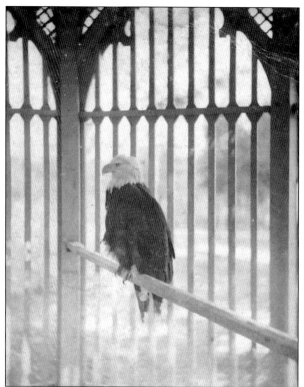

In 1865, the women of Milwaukee raised funds for a permanent soldiers' home by selling cards with the image of Old Abe, the eagle mascot of the 8th Wisconsin Volunteer Infantry. The Home's bald eagle was donated by J.D. Cabeen and resided in an ornate cage near the main building. In some accounts, the eagle is called "Joe," short for Gen. Joe Hooker; in others, "Old Abe Jr."

Below, from left to right, an unidentified child, National Home farmer William Gibson, and Gibson's sons Ralph and William seem well dressed for launching toy sailboats on the lake closest to the farm, around 1890. Farmer Gibson was described as a rosy-faced, genial Scotsman who was fond of greeting everyone with quotations from the Scottish poet Robert Burns.

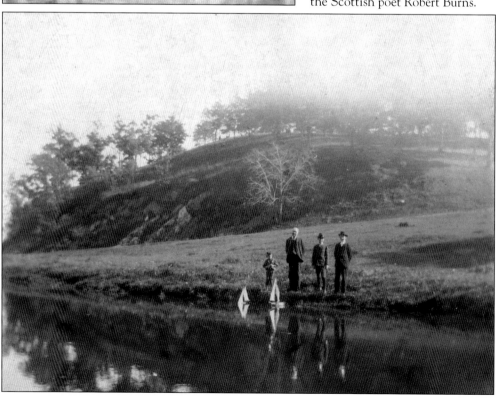

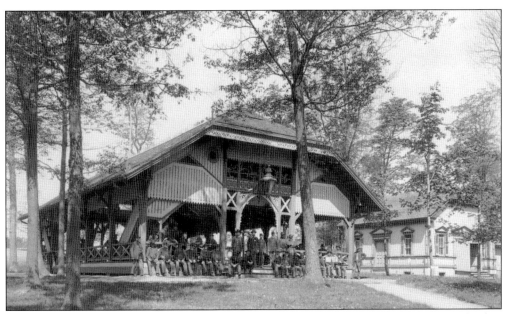

This large open-air pavilion, filled with benches, provided ample shade for picnics and other outings, and a nearby refreshment stand sold ice cream, soda water, lemonade, cigars, and candy. One of the first public events held at the pavilion took place on September 17, 1875. Couples swirled around the excellent wooden dance floor until the chilly fall air drove them indoors. (Courtesy of Milwaukee Public Library, Milwaukee Historic Photos Collection.)

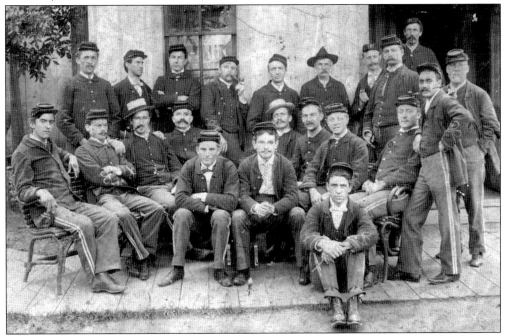

In addition to a paid brass band, the Home boasted a silver cornet band, a fife and drum corps, and the German band pictured here. According to annual reports to the board of managers, the majority of foreign-born residents at the Northwestern Branch were of German descent. (Courtesy of Milwaukee Public Library, Milwaukee Historic Photos Collection.)

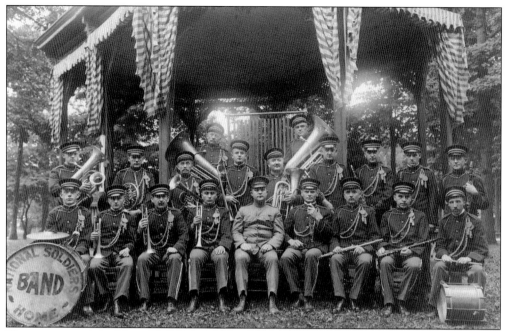

The treasurer of the Home used money from the Post Fund to pay a brass band, composed of civilians and Home members, to give open-air concerts at 4:00 p.m. every day except Monday and to furnish music at the hospital twice a week. The band also entertained throughout southeast Wisconsin, including at Milwaukee's Courthouse Park and the Bethesda Spa in Waukesha.

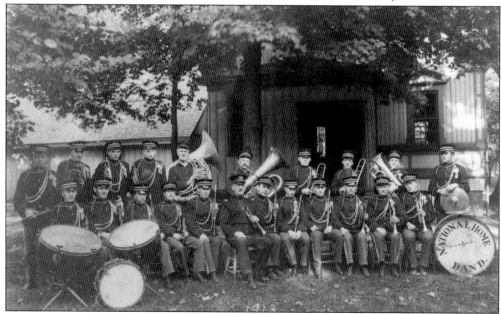

Arthur Casimir Sanger played clarinet in the Home band until enlisting as a musician and stretcher-bearer in the 32nd Division in World War I. Later, he was chosen for the US Army Band, known as "Pershing's Own," and performed in the 1919 Liberty Loan Tour to raise funds for the Allied cause in World War I. In this 1913 photograph, Sanger is seated fourth from the right. (Courtesy of Ethan Frounfelker.)

Throughout its development, the Home's system of curving roads remained essentially unchanged. In the photograph above, from the 1890s, horse-drawn carriages travel along Central Avenue. Running from the northwest to the southeast corner of the grounds, Central Avenue was connected by a network of lesser roads to residences, administrative buildings, and maintenance facilities. In 1892, the board of managers authorized the Milwaukee Street Railway Company to use part of the Home grounds for its railway running across the Menomonee Valley from downtown. Below, the elevated streetcar trestle on the northern boundary of the grounds provided a direct connection to downtown Milwaukee. Not only did visitors to the Home and to Calvary Cemetery use the line, but old soldiers hopped aboard as well. Elizabeth Corbett reported that one old soldier made regular trips downtown for little more than a cheese sandwich.

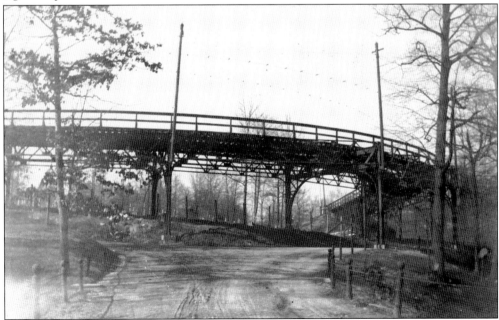

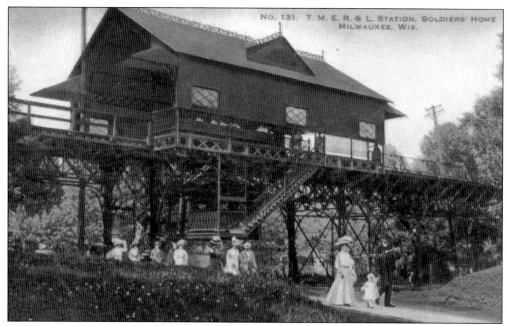

In the early days of the Home, visitors arrived by horse-drawn omnibus or carriage. By 1916, visitors had the choice of two streetcar routes from downtown Milwaukee. One line travelled from Grand Avenue and Wells Street to a depot, pictured above, within one block of the north gate. The other line ran along National Avenue and terminated at a depot on the grounds, pictured below, not far from Ice Lake. The transit time from downtown was 20 minutes, and the fare was 5¢. Public transportation of all kinds was overburdened on holidays, particularly on the Fourth of July, when tens of thousands of visitors streamed to the grounds for picnics, dancing, concerts, and the best fireworks for miles around.

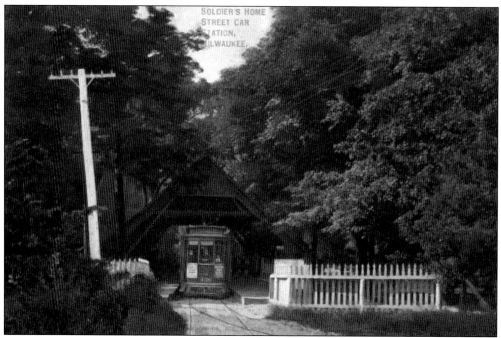

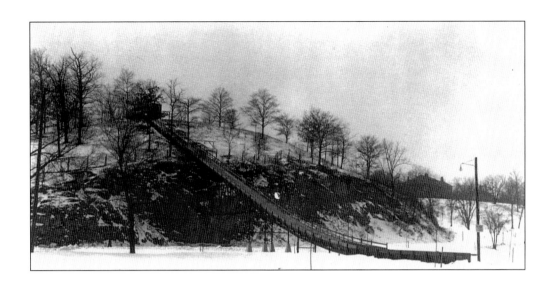

Above, a steel toboggan slide was constructed in 1934 on the south side of the Home playfield, taking advantage of the hill and rock cliff. With the slide's 79-foot drop and 295-foot run, toboggans could travel as fast as 60 miles per hour. To reduce wait times, a second track was added in 1938. In 1937, the ski slide, seen below (upper right-hand corner), was dismantled from Milwaukee's Gordon Park and rebuilt next to the toboggan slide. Its 58-foot drop and 129-foot run made it popular with beginners. The toboggan slide and ski hill were removed to make way for Milwaukee County Stadium, but young people and even some of the spry old soldiers took advantage of the gently rolling hills on other parts of the Home grounds for sledding. The band pictured below is from Swanson-Williams Veterans of Foreign Wars Post 726. (Above, courtesy of Milwaukee County Parks.)

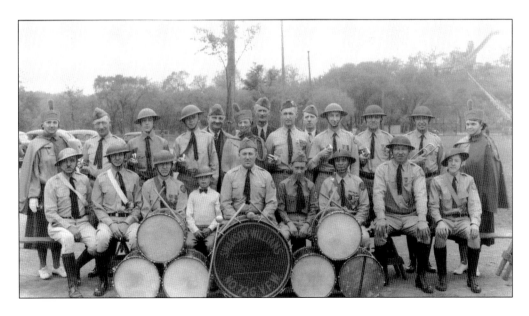

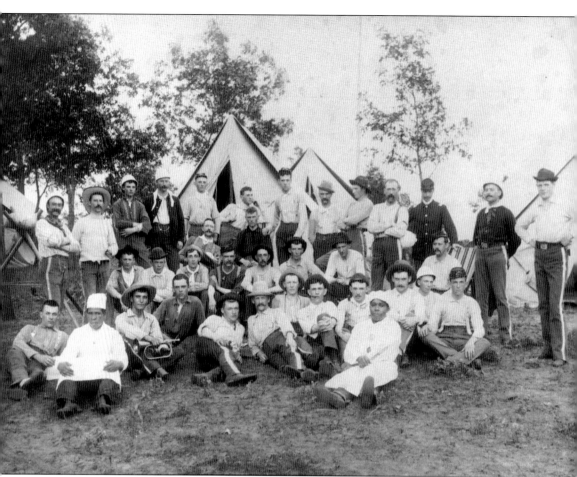

It was not uncommon for veterans to hold reunions or other gatherings at the Home. This unidentified military or veteran gathering in the 1910s features a unit complete with tents and camp cooks. On July 17, 1880, a Musical and Military Grand Gala at the Home featured promenade concerts by the Home Band and 1st Regimental Band; an exhibition drill by companies of the 1st Regiment, Illinois National Guard, and the Milwaukee Light Horse Squadron; and a dress parade by the 1st Regiment. Home members were honored to participate in the national encampments of the Grand Army of the Republic (GAR) in Milwaukee in 1889, 1923, and 1943; the national encampment of the United Spanish War Veterans in 1939; and annual patriotic observances outside the grounds. National and regional encampments also brought veterans and prominent visitors to the Home, among them Gen. Philip Henry Sheridan and Franklin D. Roosevelt during his presidential campaign. (Courtesy of Milwaukee County Historical Society.)

Four
THE VETERAN POPULATION BOOM

Construction of an expansive new hospital (Building 6) was begun in 1879 to meet the needs of an aging population of Civil War veterans. One example of the careful planning for this facility was the placement of patient rooms below the kitchen so that culinary aromas would not bother the sick and infirm. (Courtesy of Milwaukee Public Library, Milwaukee Historic Photos Collection.)

In 1879, the Northwestern Branch was authorized to spend $6,815.11 for a combined bakery and storehouse. In the 1880s, an investigation into complaints about bad bread zeroed in on a baker who had consumed all the yeast set aside for an 800-pound batch. The bakery soon was back on track, producing an average of 1,000 pounds of bread daily in addition to large quantities of buns, biscuits, cakes, and pies.

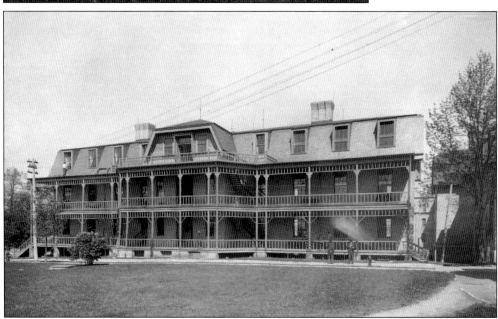

In 1884, federal legislation allowed membership for veterans from other wars who were infirm and in need of care. In this 1890 image, Civil War veterans pause in front of one of the barracks constructed to meet the demand for domiciliary space. Even with the new buildings, 132 members were discharged in March 1892 to make room for veterans with greater needs. (Courtesy of Milwaukee Public Library, Milwaukee Historic Photos Collection.)

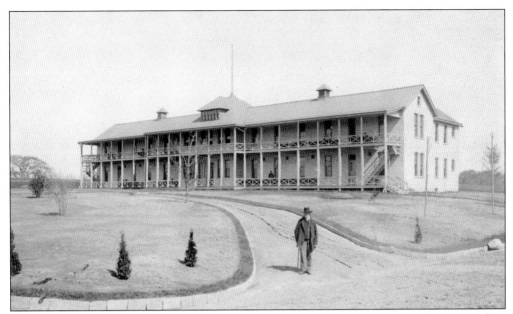

In 1893, the Northwestern Branch constructed separate quarters for elderly members, providing a model of geriatric care for other branches. The structure known as the old men's barrack was inhabited almost exclusively by Civil War veterans. Designed with the needs of aging veterans in mind, the domiciliary building had a separate kitchen and special diet for the elderly. (Courtesy of Milwaukee Public Library, Milwaukee Historic Photos Collection.)

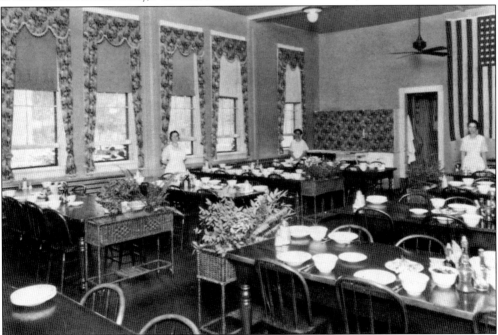

Furnishings for the dining room and sun parlors of the old men's barrack were provided by Erastus B. Wolcott Post No. 1, GAR; the Women's Relief Corps; Sons of Veterans and its auxiliary; and Daughters of the GAR. Sun parlors included easy chairs, rocking chairs, writing desks, floral stands, goldfish, canaries, Graphophones, and radio sets.

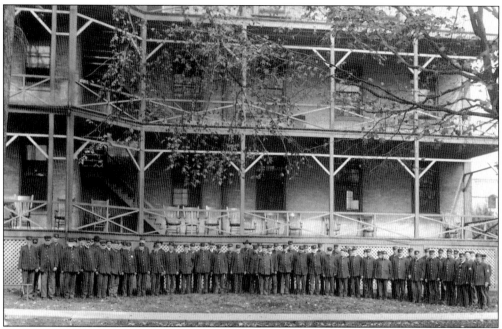

In 1916, members of all the Home companies, including Company H (pictured above), posed in front of their barracks for rare group photographs. Most domiciliary structures built in this period, out of consideration for aging veterans, had no more than two floors of living quarters. The membership of Company E (pictured below), domiciled in the main building, included one African American veteran. A 1916 annual report for the Northwestern Branch tallied a total of 12 "colored members." The average age of the 2,805 veterans receiving care that year was 66.85 years. Of these, only 373 were from conflicts other than the Civil War or Mexican War.

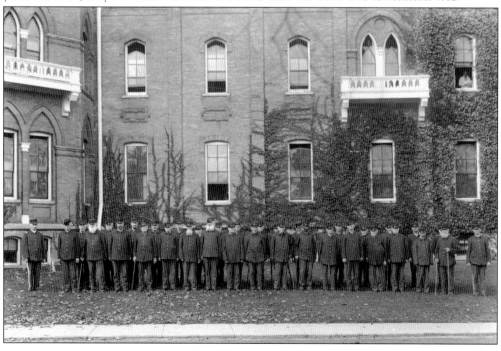

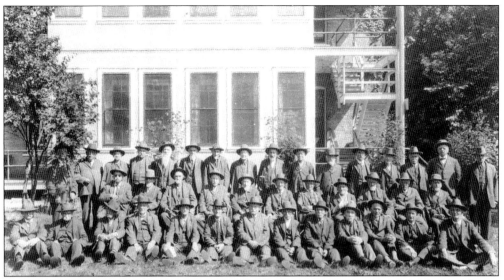

By 1920, the average age of the 1,266 Civil War veterans receiving care was 80. The population of Spanish-American War veterans had swelled to 499, and the first World War I veterans were beginning to trickle in. In 1922, hospital facilities were made available for the first time to veterans who were not living at the Home.

In this 1910 photograph, Civil War veterans pose near one of the cannons across from Old Main. Elizabeth Corbett mused that the echoes of elderly veterans' wartime experience must be growing dim. "Perhaps there is always a kind of passive tragedy," she wrote, "about meeting greatness in your twenties, and then after that simply living on, and on, and on." (Courtesy of Milwaukee County Historical Society.)

Several Civil War veterans in these 1928 photographs of Company 8 wear GAR medals, and one proudly displays his pet birds. In 1928, Veterans Post No. 8, which was organized at the Home in 1867 as Yates Post No. 84, had 174 members. With the GAR's growing popularity, a second post, Old Guard Post No. 211, was chartered at the Home on May 17, 1898. Records for 1928 show only 377 Civil War veterans in residence, while the number of Spanish-American War veterans had grown to 1,363. The number of World War I veterans had risen to an astounding 3,758.

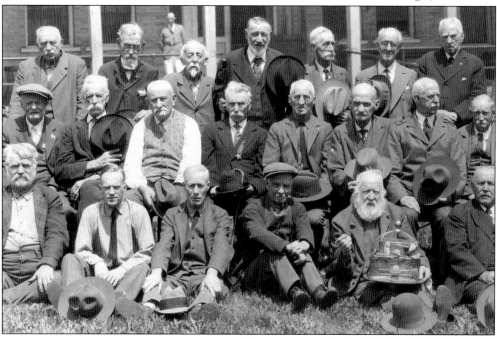

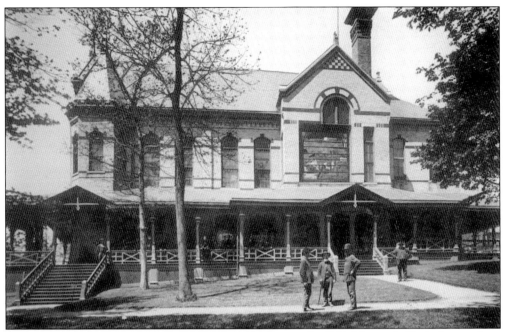

In 1881, Henry C. Koch designed the Ward Memorial Hall (above) as a two-story, multipurpose facility with a meeting room, store, restaurant, and railroad ticket office. A magnificent stained-glass portrait of Gen. Ulysses S. Grant was installed in 1887. It was the gift of Ransome Post No. 171, GAR, St. Louis, Missouri, and citizens of that city following the National Encampment of 1887.

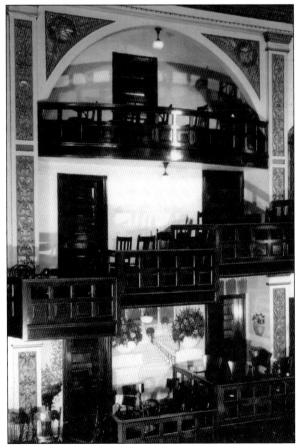

In 1898, Ward Memorial Hall was redesigned as a one-story theater with a sloped floor, balcony, and boxes flanking the proscenium stage. It could accommodate 800 veterans and visitors, and entertainment was offered at least three times a week by professional and local theatrical companies and societies. For many years, the YMCA contributed weekly programs (except during very hot weather).

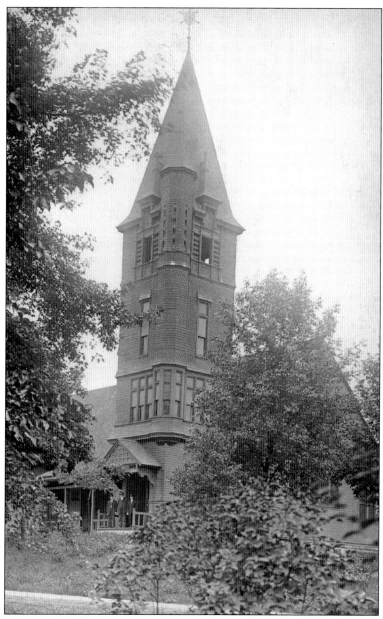

With the increasing need for domiciliary beds in the main building, religious services were conducted in the Ward Memorial Hall until 1889, when a handsome wood-frame chapel was built west of the general hospital (Building 6). The Home chapel was funded in part by the Post Fund, an amount accumulated from sales of products made or grown at Home. Clergymen of several denominations, including the Protestant and Catholic chaplains in residence, held services several times a week. A magnificent bell, donated by benefactors in Milwaukee and installed in 1893, pealed for worshippers and for children (of staff members and from the neighborhood) who attended its Sabbath School. Stained-glass memorial windows were added in later years. Flowers for the altar were provided from the Home greenhouse. Several groups, including the Woman's Christian Temperance Union, held services in the chapel. Eventually, the chapel had its own organ and paid choir.

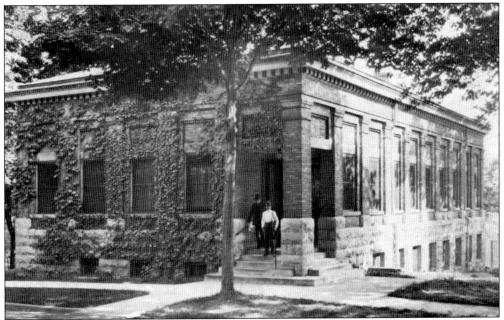

The 1891 Wadsworth Library was built with funds from sales at the Home, including profits from the beer hall. Around 1905, it was named in honor of Maj. James W. Wadsworth, US senator and president of the board of managers. At times, the basement provided temporary barracks space; it later served as a meeting place for the Explorers Club, an all-resident recreational group. (Courtesy of Milwaukee Public Library, Milwaukee Historic Photos Collection.)

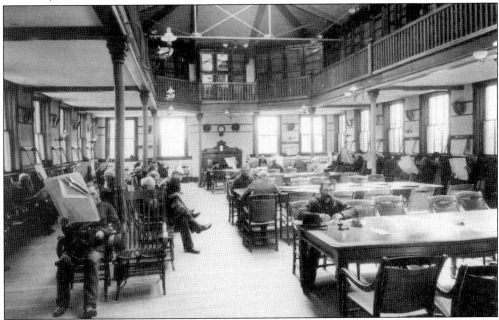

A large skylight supplements the interior lighting in this 1894 photograph. The walnut bookcases lining the gallery had been moved from the main building. When members requested books from the closed stacks, the librarians used a pulley system to deliver their orders from the gallery level to the first floor.

The laundry building was completed in 1891 for $7,500. In June 1909, a dry-cleaning plant was added, and in December 1910, a new laundry machine was installed. Before leaving on furlough or being discharged, each member was required to turn his federally issued clothing over to the quartermaster for dry cleaning and restoration.

Built in 1894, the recreation (or social) hall had two floors and a basement. The basement was furnished with card tables, checkers, chess, and pocket-ball boards. The first story included a billiard room with two billiard tables and four pool tables. The second story housed a GAR post hall, which served a variety of patriotic groups.

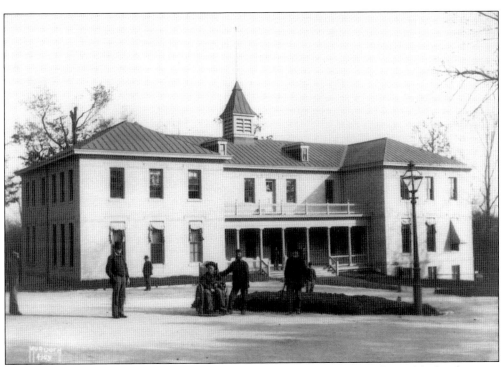

The governor, treasurer, quartermaster, and adjutant had offices on the first floor of the headquarters building, pictured above, which is attributed to architect Henry C. Koch. The second floor served as reading and sleeping rooms for the administrative clerks, and a print shop and bindery were located in the lower level. This building served as the main offices of the VA medical center until 1942. Below, the quartermaster storehouse was conveniently located along a spur of the Chicago, Milwaukee & St. Paul Railway. Both buildings were completed in 1896 and are still in service. As with the majority of buildings at the Home, the headquarters building and the storehouse were built of Cream City brick.

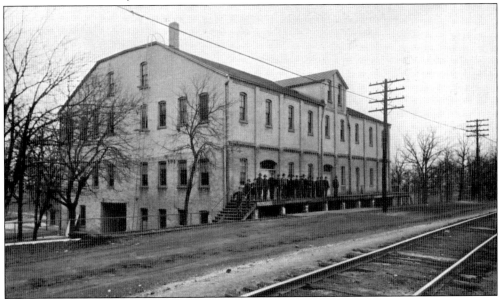

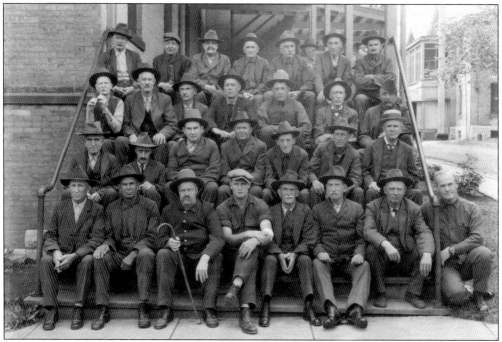

When this photograph was taken in 1920, Home members who were veterans of the Spanish-American War numbered 499. Service organizations from this era were active for decades at the Home, taking a leading role in the creation of memorial forests in the 1930s. In 1941, United Spanish War Veterans commissioned *The Hiker*, a statue near Lake Wheeler, in memory of the men who had survived hard marches under the tropical sun.

The isolation hospital was located on the northeast portion of the grounds, as removed as possible from residents and staff. Constructed with brick veneer, it had three rooms and a basement and was furnished with electric lighting, a hot-air furnace, its own cooking facilities, and a telephone. Records note that the last member to live in the building suffered from leprosy. By 1912, it was no longer in use.

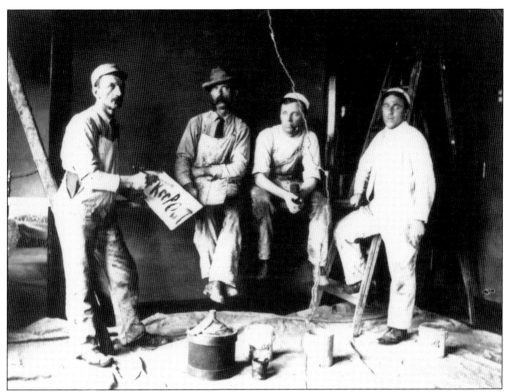

When VA employee Ken Bonn found the 1910 photograph above in the archives of the VA electric shop, he was surprised to recognize that the painter holding the Keep Out sign was his grandfather Albert Bonn. From the very beginning, members of the Home were assigned about one half day's light labor each week. A June 30, 1884, report to the National Board of Managers lists former occupations of Home members, counting 41 blacksmiths, 46 clerks, 46 tailors, 49 painters, 64 shoemakers, 83 carpenters, 436 farmers, and 702 laborers. As late as the 1930s, members were employed as elevator operators, gardeners, carpenters, painters, plumbers, steamfitters, mess attendants, janitors, buglers, assistant librarians, company commanders, company sergeants, readers for the blind, radio operators, and motion-picture operators. At right, in an undated photograph, an employee (possibly a Home member) shovels refuse into the incinerator.

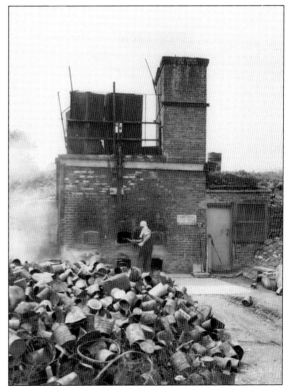

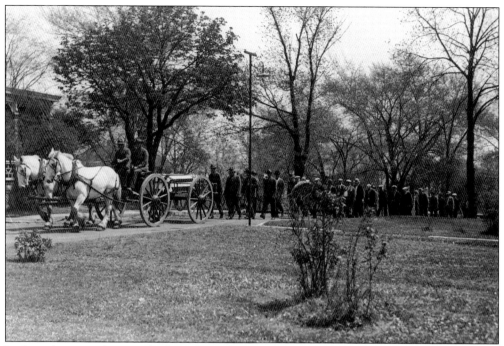

In these dramatic photographs from the early 1910s, a funeral cortege winds its way to the Home cemetery. Elizabeth Corbett recalled that, at the turn of the 20th century, "there was a funeral almost every day First marched the fife and drum corps. Then came the firing squad, with muskets reversed. The coffin was carried on an artillery caisson and covered by a large American flag. Behind it marched a detail from the deceased veteran's Home company." In 1937, Wood Cemetery began allowing burials of all veterans, not just those who lived at the Home. In 1973, it became Wood National Cemetery. (Courtesy of Milwaukee County Historical Society.)

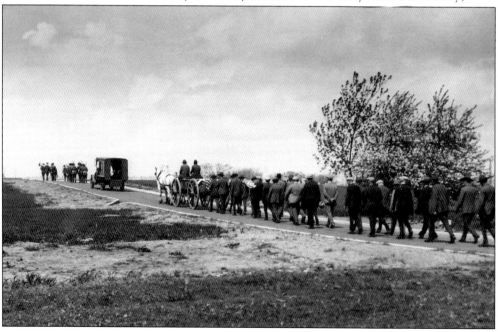

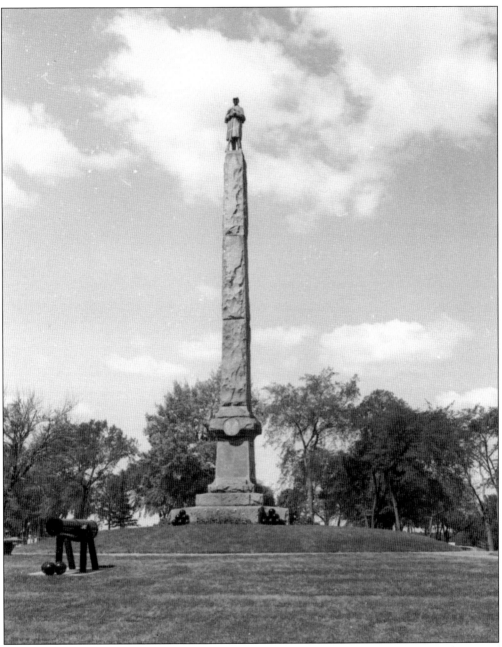

The Soldiers and Sailors Monument, dedicated in 1903, remains the most prominent feature of Wood National Cemetery. The striking granite monument, constructed by the Joseph Shaver Granite & Marble Company of Milwaukee, rises 65 feet. The stepped base is topped by a pedestal and three-part shaft. A Civil War Union soldier at parade rest crowns the monument. The base, engraved with an anchor, crossed swords, and crossed cannons, bears the simple inscription, In Memory of Comrades Buried in this Home Cemetery. Pyramids of cannonballs decorate the corners of the base. The cannon in this photograph is one of several predating the monument itself. In 1870, after the ordnances had been judged unfit for use by the Army, Congress directed the secretary of war to transfer them to the Northwestern Branch for display use only in the cemetery.

When Old Main, pictured above, opened in 1869, it had a 500-bed capacity. By 1895, all the branches of the Home were so crowded that members were sleeping in basements and attics. Even though other barracks had been built, Old Main was pushed beyond its limit several times, housing close to 1,000 men. When elevators were installed in 1883, members who had previously had to make the slow, painful climb to the upper floors were greatly relieved. The advent of the automobile brought even more changes on the grounds, including the construction of garages and maintenance facilities. Below, an early car is parked in front of the social hall in this postcard from the 1910s. Before long, automobiles and bus service were necessary for veterans to travel to the growing number of buildings on the campus.

Five
THE OFFICERS, STAFF, AND FAMILIES

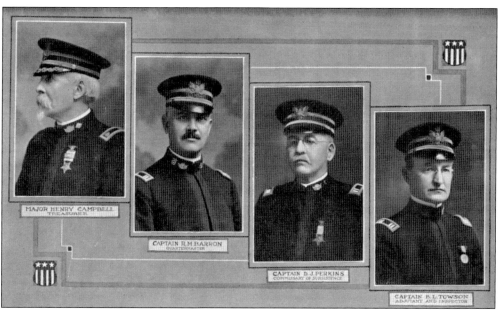

In 1916, the Home officers included, from left to right, Maj. Henry Campbell, treasurer; Capt. R.M. Barron, quartermaster; Capt. D.J. Perkins, commissary of subsistence; Capt. B.L. Towson, adjutant and inspector. The governor of the Home was Col. T.H. Ijams, and the surgeon was Maj. Vernon Roberts.

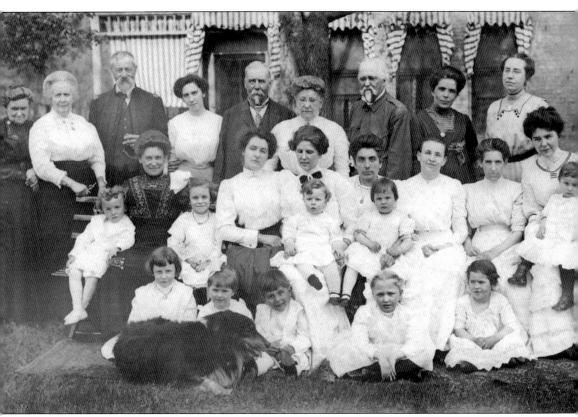

Some of the extended families of the Home staff and a dog thought to belong to Gov. Cornelius Wheeler pose for this photograph during a children's party in 1912. Pictured are, from left to right, (first row) Laura Chrysler, Elizabeth Collins, an unidentified boy, Florence Anderson, and an unidentified girl; (second row) Frederick Chrysler, Birdseye McPherson Chrysler (the chief surgeon's wife), Harriet Chrysler; Mabel Collins; Ruth Moore (wife of the chief clerk in the treasurer's office), Harrison Eugene Moore (on his mother's lap), Alice Allen (holding one of her children), Mary Anderson (the plumber's wife), Nellie Allen, Emma Hickman (organist and choir mistress), and Frances Hickman Anderson (on her aunt's lap); (third row) Georgiana Wright (wife of the Protestant chaplain), Margaret Valentine (wife of the adjutant), Capt. Charles O. Collins (commissary of subsistence), Marion Smith, Charles O. Hickman (engineer), Annie Knox (hospital matron), Governor Wheeler, Alice Hickman, and Bessie Hickman (choir member).

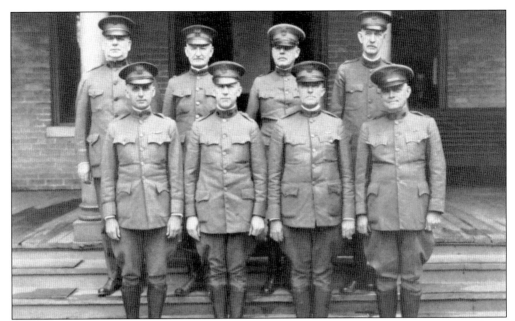

In 1924, officers pose for a photograph on the steps of the headquarters building. Pictured are, from left to right, (first row) Col. Charles M. Pearsall (governor), Lt. Col. M.W. Snell (surgeon), Maj. C.E. Newton (treasurer), and Capt. Cyrus H. Lyle (quartermaster); (second row) Rev. Michael J. Huston (chaplain), Capt. B.L. Towson (adjutant), Rev. M.W. Argus (chaplain), and Capt. T.J. Colfer (commissary).

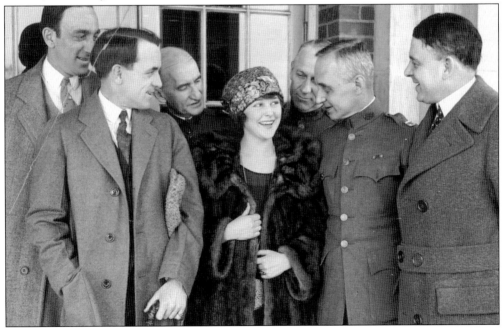

Members of the administrative staff, including Col. Charles M. Pearsall (second from right) are attentive to an unidentified celebrity in their midst. Maj. Paul G. Froemming (far left), however, did not have far to go to see a beautiful starlet. His wife, Ruth Foster Froemming, was a cast member of the 1919 Ziegfield Follies. (Courtesy of the *Milwaukee Journal Sentinel*.)

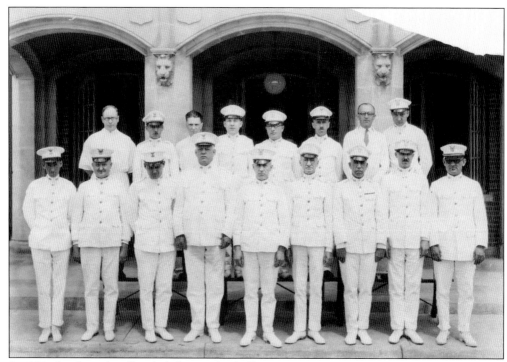

In 1923, the clinical staff included 17 medical officers, pictured here in front of the administration wing of the tuberculosis hospital (Building 70). The Home also employed consultants in several specialties—including surgery; eye, ear, nose, and throat; genitourinary; and neuropsychiatry. The staff had access to up-to-date laboratory and X-ray equipment, including bedside machines.

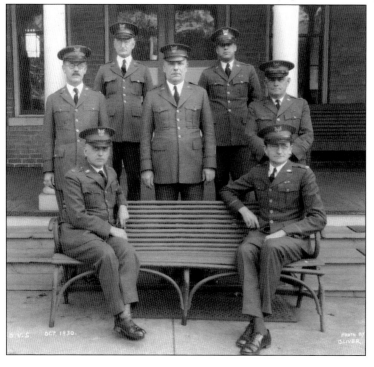

In 1930, following the transition from National Home to Veterans Administration, a group of Home officers poses in front of the headquarters building. The insignia on the men's caps is a combination of an eagle and the Home badge. Officers wore the Home badge on each lapel, while medical staff wore a pair of pins with the caduceus (a symbol of medicine in the United States) in addition to the Home badge.

Col. Charles M. Pearsall became affiliated with the National Home in 1903, serving as quartermaster, treasurer, inspector general, and governor. When the National Home, Pension Bureau, and Veterans Bureau consolidated as the Veterans Administration on July 21, 1930, he was named manager of Milwaukee's combined facility. Pearsall transferred to the VA facility in Leavenworth, Kansas, on April 29, 1942.

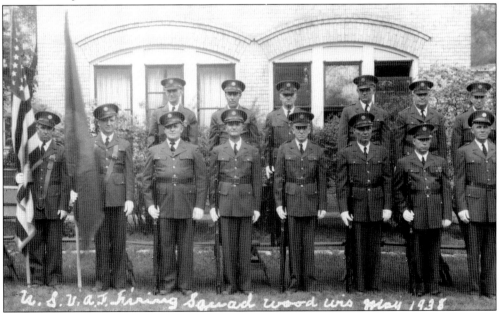

In 1938, the Home firing squad has lined up for a photograph in front of the converted 1883 firehouse. The firing squad served in a number of ceremonial roles, but none as important as providing a salute at military funerals at Wood Cemetery. When the Milwaukee Fire Department started providing services to the Home, the on-site firehouse was converted to living quarters.

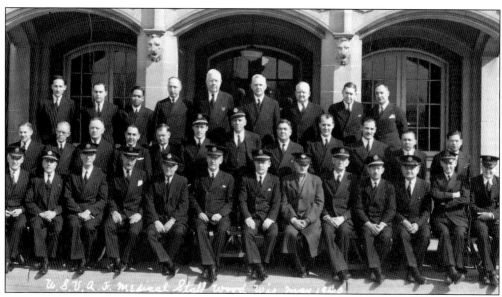

This section of a 1940 photograph shows the medical staff in front of the general hospital (Building 70). The only physicians identified are Dr. Slaybaugh (first row, second from left) and Dr. Primakow (middle row, fourth front left). Lt. Col. A.B. Thompson, MD, was the chief of staff from 1926 to 1941.

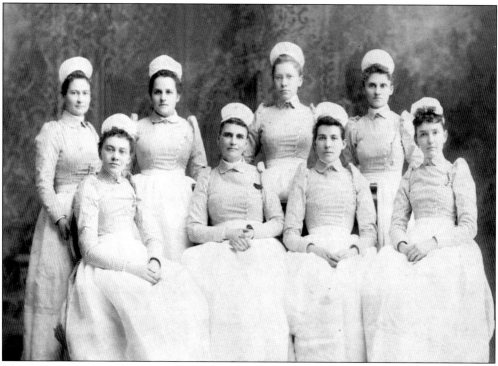

Thanks to Sen. John L. Mitchell, the Milwaukee Home was the first branch to train and employ professional female nurses. These women, pictured in May 1890, are from the first graduating class of the Wisconsin Training School for Female Nurses. Last names penciled on the back of the photograph include Myers, Mauley, Wehrman, Anderson, Neal, Holmes, Keisling, and Rausch.

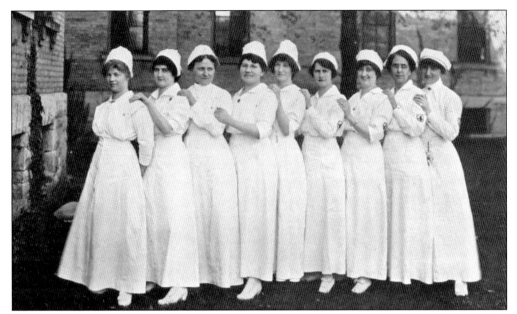

Female nurses proved to be a source of comfort for the old soldiers. The medical staff noted improvements in the appearance, habits, and conversation of their patients, as well as a new sense of contentment. Assistant surgeon Doctor McIlvaine said, "The occupants of this house will not cease to bless Col. John L. Mitchell . . . until they go to rest over in the cemetery."

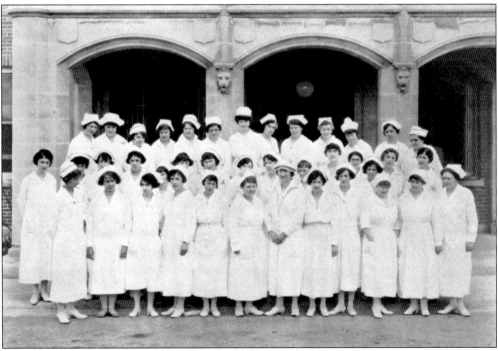

This 1924 photograph shows a group of nurses in front of the new tuberculosis hospital (Building 70), one of several across the nation commissioned by the federal government to meet the influx of patients after World War I. At one time, nurses were on duty from 7:00 a.m. until 10:00 p.m. They had only a few days off and were scheduled for additional duty every third night.

Nurses' quarters, originally constructed in 1901 for $3,800, were located on Wolcott Avenue, west of the chapel and just north of the 1879 hospital. To accommodate the growing number of nursing staff, including those who served the tuberculosis hospital, quarters were expanded with a frame addition in 1921 and a brick addition in 1923.

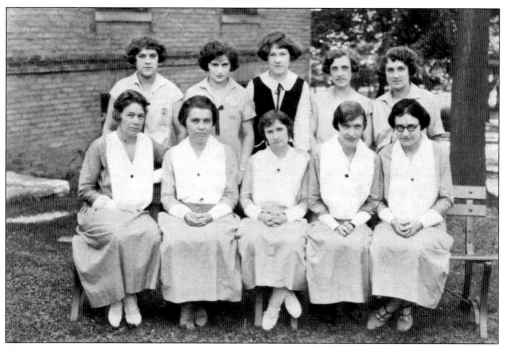

This group of American Red Cross workers is featured in the Home's 1924 souvenir book. The Red Cross provided a corps of 17 aides to supplement the work being done by representatives of the YMCA and the Knights of Columbus. These organizations offered assistance with compensation and legal matters for World War I veterans living at the Home.

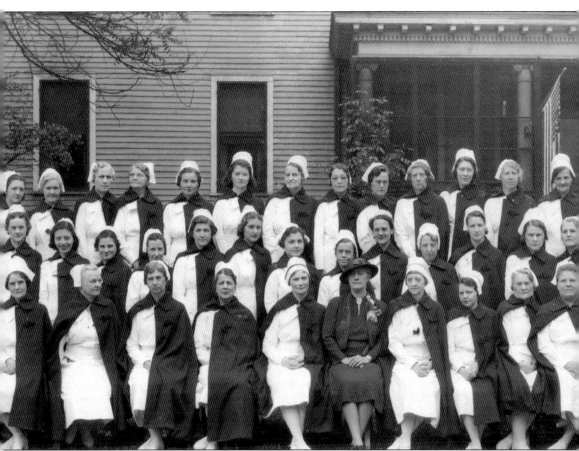

On Memorial Day 1939, VA nurses pose in front of their quarters for a photograph with visiting chief nurse Hickey from Washington, DC. By this time, the Northwestern Branch had been renamed in honor of George Wood, former president of the National Home's board of managers, and was known simply as Wood. The photograph key does not include any first names for the nurses; they are, from left to right, (first row) Ms. Jangles, Ms. Turner, Ms. Doerning, Ms. Kindt, Ms. Metcalf (chief Wood Nurse), Ms. Hickey (chief VA nurse), Ms. Petty (assistant chief Wood nurse), Ms. Linder, Ms. Helmich, and Ms. Peterson; (second row) Ms. Miller, Ms. Frey, Ms. Clark, Ms. Weir, Ms. Wilsner, Ms. Reeves, Ms. Classon, Ms. Vallette, Ms. Westman, Ms. Schott, Ms. Westbrook, Ms. Shallow, and Ms. Wartman; (third row) Ms. Zimmerman, Ms. Gailfoyle, Ms. Mieres, Ms. Cody, Ms. Zibbell, Ms. Kathlow, Ms. Lange, Ms. Bickley, Ms. Rudh, Ms. Qualley-Dubois, Ms. Hendry, Ms. Oster, and Ms. Schielck.

At each branch, the officer responsible for overall operations of the Home was known as the governor, general superintendent, or commandant. The governor served at the discretion of the National Home's board of managers and had at his disposal an administrative and professional staff consisting of a deputy governor, treasurer, surgeon, quartermaster, commissary of subsistence, adjutant-inspector, and chaplain. In 1916, noncommissioned staff (above) and clerks (below) assembled on the steps of the administration building. In the early days of the Home, some of the clerical roles were filled by old soldiers, until their advancing years brought job openings for civilians.

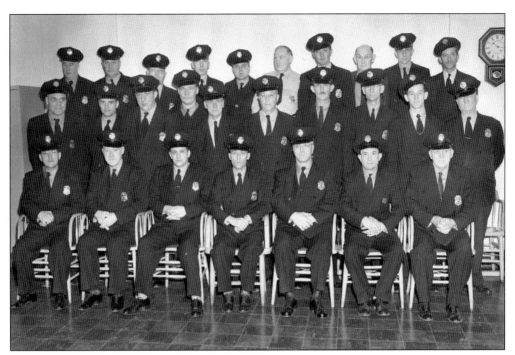

After formation of the Veterans Administration in 1930, the Home police force was reorganized under the VA Protective Service. This force, pictured around 1950, was charged with maintaining order, protecting persons and property, and ensuring fire safety. In time, the responsibility for fire safety was transferred to the engineering department.

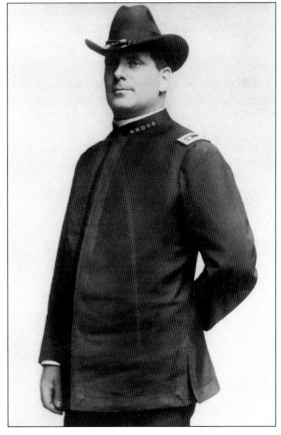

Rev. Michael Huston, a native of Ireland, was commissioned to the Soldiers' Home chaplaincy on July 1, 1903, serving as the first resident Catholic chaplain. Along with the Protestant chaplain, he presided at services at the chapel and ministered to the sick in hospital. Under a 1932 government regulation, he was forced to retire at age 70.

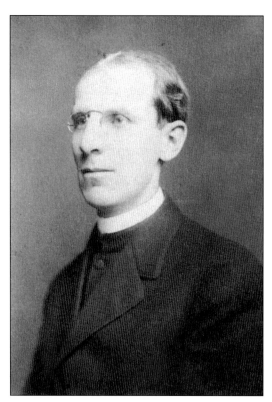

Rev. Dr. E. Purdon Wright was appointed Protestant chaplain of the Home on April 7, 1890. Elizabeth Corbett recalled that he wore the most beautiful, shiny vestments that she had ever seen, carried himself with the natural dignity of a highbred Englishman, and had a sparkle in his eyes that betrayed his Irish lineage. (Courtesy of Milwaukee Public Library, Milwaukee Historic Photos Collection.)

Georgiana Wright, the wife of the beloved Home chaplain, was a source of inspiration for budding author Elizabeth Corbett. It was no secret that Mrs. Wright was the model for Mrs. Meigs, the central character in many of Corbett's popular novels. (Courtesy of Milwaukee Public Library, Milwaukee Historic Photos Collection.)

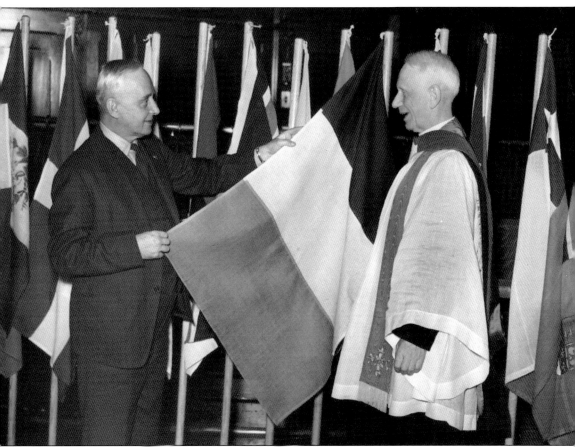

Rev. Dr. Gustav Stearns (right) served as Protestant chaplain from 1934 to 1947. Prior to his service at the Home, he was chaplain of Wisconsin's 32nd Division in World War I and captain in the 127th Infantry, 32nd Division. During his service, he was known as the "Fighting Chaplain"; in his ministry in Milwaukee, however, he was celebrated as the "Marrying Chaplain." In July 1934, during his tenure at the Home, he officiated at his 1,000th wedding. In this photograph with Col. Charles M. Pearsall, Stearns shows some of the flags that had been received by mail from countries all over the world. Stearns built the collection as a hobby, taking six years to correspond with each of the countries belonging to the United Nations. The flags were displayed in the Home chapel as tokens of goodwill among nations and all people. Flags were also displayed at the annual Massing of the Colors before Memorial Day. This unique collection is mentioned in the 1942 World Almanac. (Courtesy of the Milwaukee Journal Sentinel.)

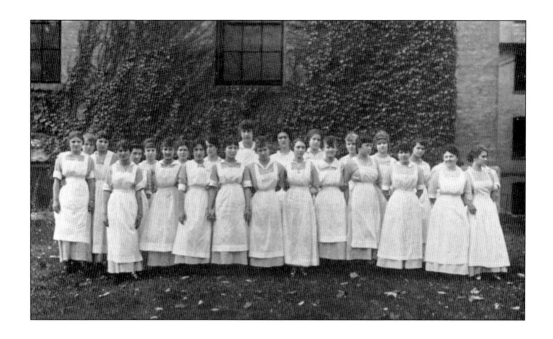

By 1916, waitresses, seen above, were employed in the large dining hall of the main building, as well as at the smaller specialty dining room in Company M. Steaming dishes were brought in from the kitchen on three-tiered, wheeled trays. Home members were allowed half an hour for meals in the dining hall of the main building, but often finished and departed well before time was up. In 1884 alone, six male laundry employees processed 274,849 pieces of laundry. As the Home population increased, additional laundry workers, seen below, had their hands full with clothing and linens for close to 1,000 members and staff.

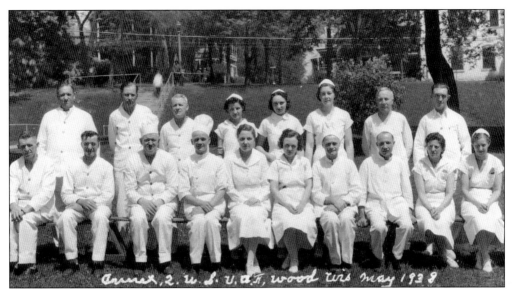

Annex 2, the facility for chronically ill veterans, employed these cooks and kitchen helpers in May 1938. While ample, nutritious meals were always the goal, the science of hospital dietetics was still developing. By 1967, Wood VA employed 14 dietitians and 300 dietetic assistants, serving approximately 2,100,000 meals each year.

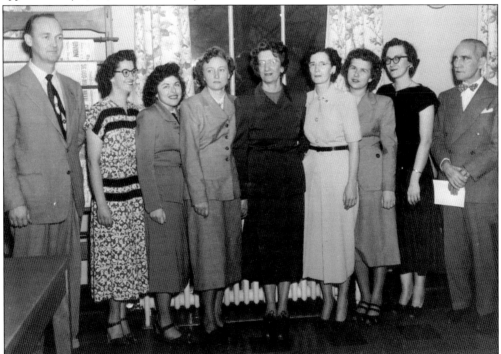

Staff members gather for the 1949 open house at the Wadsworth Library. Pictured here are, from left to right, Earl M. Accola (chief of special services), Anne C. Rukavina, Esther Richard, Elvera E. Johnson (assistant chief librarian), Florence Markus (chief librarian), Jeanette Huston (medical librarian), Genevieve Chycowski (clerk typist), Dorothy Kopetsky, and W.N. Gregg (assistant manager).

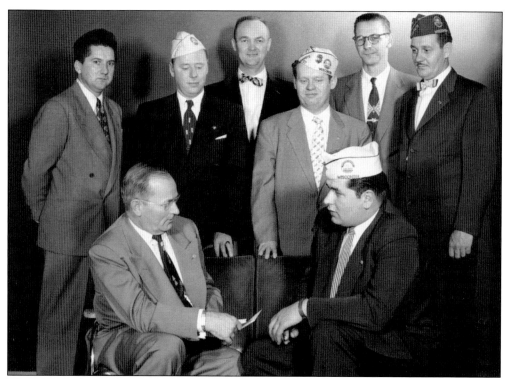

The support of veterans organizations was critical for patient care and morale in the 20th century. On April 6, 1955, Wood VA director Delta C. Firmin (seated at left) met the AMVETS state commander, Edwin J. Nelson. Standing, from left to right, are Vick J. Brule, domiciliary manager; Paul L. Shave, AMVETS national service officer; Earl M. Accola; Jerry Arnold, AMVETS; A.A. Hosinski, Wood VA registrar; and Harley Erbe, AMVETS.

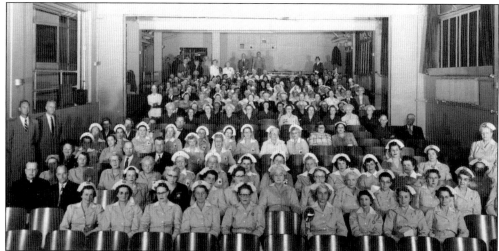

Volunteers and administrators fill the theater of the general hospital (Building 70) for a recognition ceremony. Seated prominently in the first rows are members of the American Red Cross known as Gray Ladies. In 1946, representatives of six veteran and welfare organizations and representatives of the Veterans Administration met in Washington, DC, to establish the voluntary service program. By 1967, Wood VA was receiving support from 51 organizations.

Six
THE NEIGHBORHOOD AND NEIGHBORS

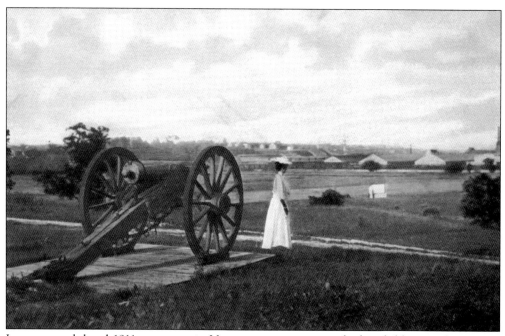

In a postcard dated 1911, a woman in Victorian attire, seemingly dwarfed by one the Home's cannons, looks east toward the industrial corridor of Milwaukee and West Milwaukee. In 1867, the location of the Northwestern Branch was described as "near Milwaukee." At that time, the Home grounds were bordered by Wauwatosa and what would become the village of West Milwaukee and the city of West Allis.

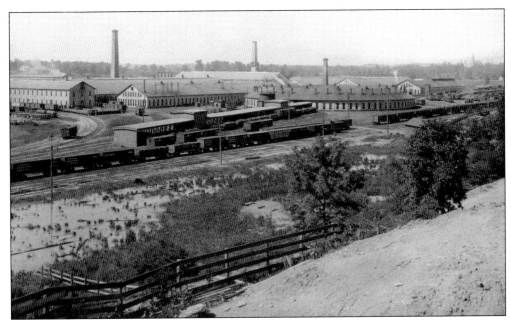

The main building is visible on the right horizon of this 1885 view of the Chicago, Milwaukee & St. Paul Railway shops. Allis-Chalmers Manufacturing Company was located west of the Home, and the Pawling & Harnischfeger Machine and Pattern Shop was located east of the National Avenue entrance. (Courtesy of the Archives Department, University of Wisconsin-Milwaukee Libraries.)

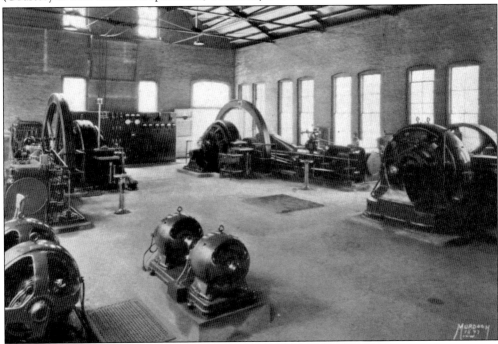

The engine room of the Home's powerhouse featured two steam engine generators, each consisting of a Corliss steam engine driving a 375-kilowatt, 230-volt direct-current generator connected to a mammoth non-condensing engine. These units, built at the Allis-Chalmers Manufacturing Company in West Allis, are featured in the Home's 1924 souvenir book.

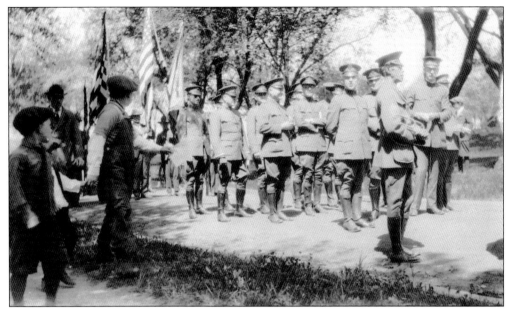

Young boys look on as officers of the Home form up for the 1924 Memorial Day observance at the Home cemetery. Neighborhood children, including a few ambitious salesmen, frequented the grounds; among these youthful entrepreneurs was Walter Funke, a lifelong resident of West Milwaukee. Funke sold ice cream, calling attention to his wares with his slogan: "Give your tongue a sleigh ride."

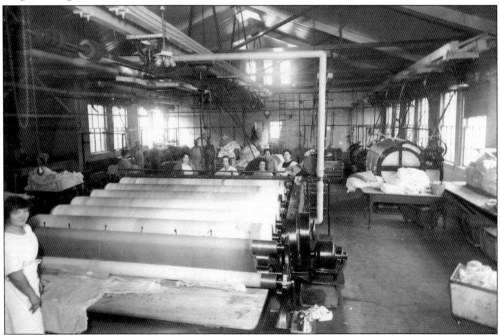

The Home provided employment for residents of West Milwaukee, including Christine Thekan, one of the women in this photograph. In 1894, the Home boasted that improved modern machinery, operated under strict sanitary regulations, was able to process 37,000 pieces of linen and clothing and to dry clean 700 pieces of clothing every week. (Courtesy of West Milwaukee Historical Society.)

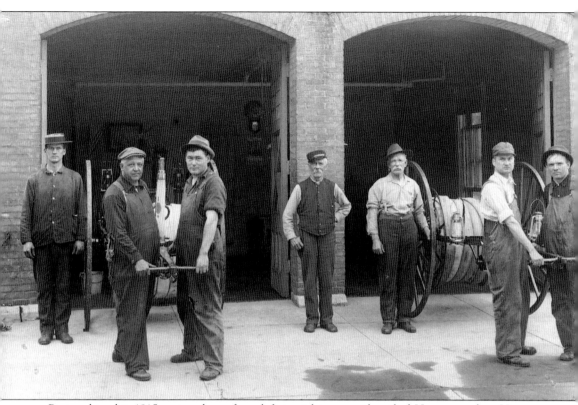

Pictured in this 1915 postcard are, from left to right, an unidentified Home member, Herman Bliesner, Clarence Bliesner, another unidentified Home member, ? Mielke, ? Schimmell, and ? McKay, standing in front of the 1883 firehouse. Herman Bliesner, the Home's boiler operator, lived on the grounds with his family and was on call around the clock. He also served on the fire crew, along with other employees and members of the Home. When Bliesner retired in 1937, he insisted on living within walking distance. Rising every day at 6:00 a.m., he made his way over to the grounds to kibitz with veterans and former coworkers. Before returning home, he usually stopped at one of the local taverns frequented by veterans. His sons, Clarence and Hilbert "Hip" Bliesner, stayed in the neighborhood as well, running the Phillips 66 station at the intersection of West Greenfield Avenue and West Beloit Road. (Courtesy of West Milwaukee Historical Society.)

Old soldiers line the porch of Paul Scheits's tavern on South Forty-Fifth Street. Concerned about disciplinary problems related to alcohol abuse, Gov. Cornelius Wheeler refined a pass system for travel outside of the grounds and encouraged veterans to take an experimental treatment for alcoholism known as the Keeley Cure. While the cure was short-lived, Wheeler noted a drop in discipline cases from 2,116 in 1892 to 1,070 in 1893. (Courtesy of West Milwaukee Historical Society.)

The patrons pictured at the saloon of Mina Gleiss (seated) include several old soldiers. A member who returned to the Home grounds intoxicated or who violated any other rule lost his pass for a period of three months. For the second offense, he was deprived of the pass for six months, and for the third offense, he was recommended for discharge from the Home.

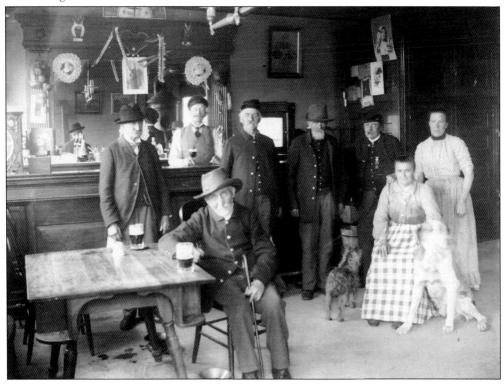

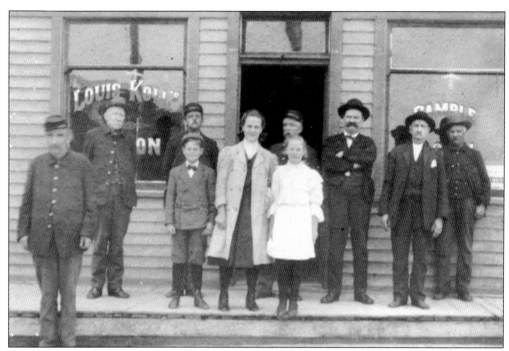

Tavern keeper Louis Koll (third from right) stands in front of his popular old-soldier watering hole with his wife, Lucy (center), and their children George and Gertrude. Louis Koll's Saloon was located at 4417 West National Avenue, not far from the Home's southern gatehouse. (Courtesy of West Milwaukee Historical Society.)

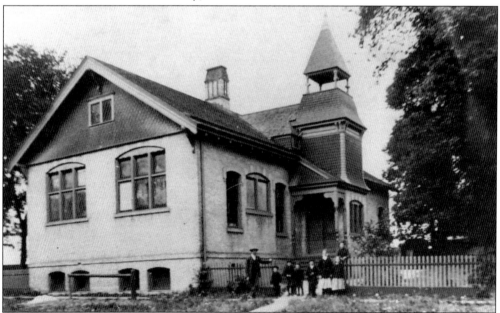

While some children of the of the Home staff attended school in downtown Milwaukee, others may have attended the National Soldier's Home School on the northwest corner of South Forty-Sixth Street and West Beloit Road. In later years, the building was used by St. Florian's Parish and School. (Courtesy of West Milwaukee Historical Society.)

Until they had their own facilities, West Milwaukee School and Pershing School held graduation exercises at the Ward Theater, also known as Memorial Hall. A graduation program is seen at right. One of the illustrious graduates of West Milwaukee High School was Wladziu Valentino Liberace, known locally as "Wally" and on the world stage as Liberace. Liberace grew up at 4905 West National Avenue, just across from the Home. It is popularly believed that, as a teenager, he entertained Home members at piano recitals at the Ward Theater. In the photograph below, Liberace (far left) is seated with his sister Angelina Liberace as members of the West Milwaukee Lions Club make him a lifetime honorary member. (Courtesy of West Milwaukee Historical Society.)

The Class of 1915

of the

West Milwaukee School

request the pleasure of your presence

at their

Graduating Exercises

in Memorial Hall, Soldiers' Home

Thursday, June Twenty-fourth

Nineteen Hundred Fifteen

Eight O'clock.

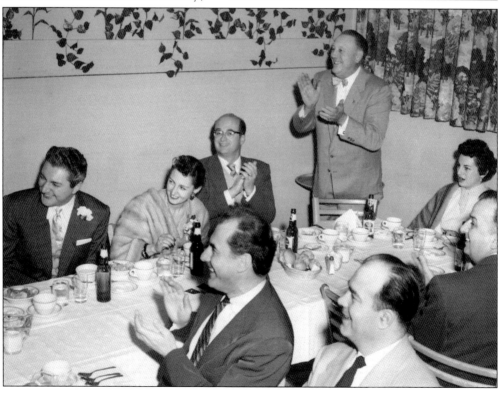

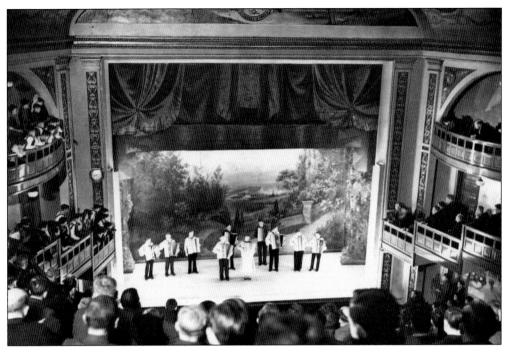

It was standing room only for this accordion concert at the Ward Theater. As West Milwaukee resident Elizabeth MacGregor Hawes remembered, "We children lived for Friday-night movies held there. The theater was a part of our lives—along with the iron pump and chained tin cup from which we all drank, soldiers in blue and all the kids, too." (Courtesy of Milwaukee Public Library, Milwaukee Historic Photos Collection.)

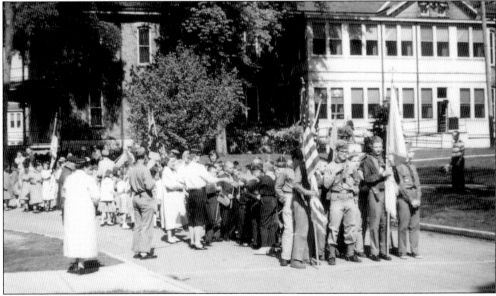

Den mother Edie Wurcer (center, in long white coat) forms her Cub Scouts into marching order for the Home's Memorial Day observance, around 1962. Members of Wuerzer's Cub Scout pack from nearby St. Florian Church were proud of all of their patriotic activities. They also enjoyed sledding on the rolling hills of the Home grounds. (Courtesy of West Milwaukee Historical Society.)

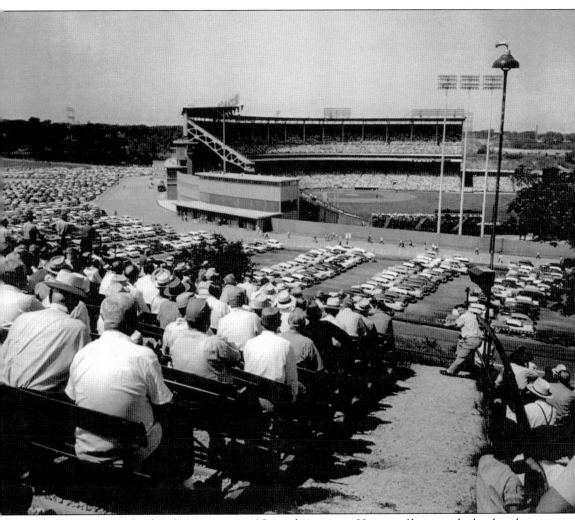

In 1928, the City of Milwaukee was given a 25-year lease to use 22 acres of low, marshy land in the northeast corner of the Home grounds for an athletic field. The city operated the Soldiers Home Playfield at this location, giving Home members free use of the facilities. In time, the acreage doubled, and the city added softball and hardball diamonds, as well as soccer and football fields. The lease was renewed in 1947, paving the way for County Stadium, a major-league ballpark. The Braves relocated from Boston for their first season at the stadium in 1953. Bleachers constructed and reserved for VA patients and domiciliary residents were located behind the right-field fence on the bluff overlooking the ballpark. Fans were downhearted when the Braves left in 1966, but rejuvenated in 1970, when the Brewers came to town. The veteran bleachers fell into disuse when right-field bleachers and a modern scoreboard obscured the view. The bleachers were torn down prior to construction of Miller Park, the current home of the Milwaukee Brewers. (Courtesy of Milwaukee County Parks.)

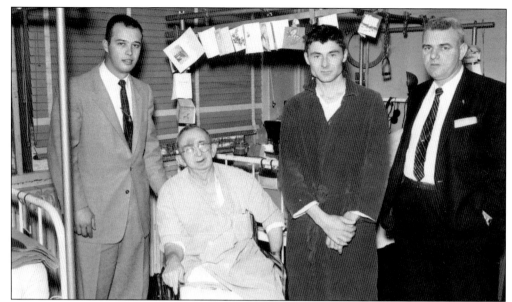

Eddie Matthews was just one of County Stadium's neighbors to visit hospitalized veterans. Matthews played third base for the Milwaukee Braves from 1953 to 1965 and was inducted into the Baseball Hall of Fame in 1978. In this photograph from December 16, 1955, Matthews (left) joins the annual effort to spread holiday cheer.

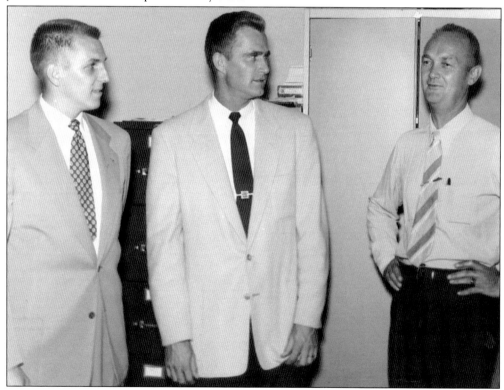

Here, Milwaukee Braves pitcher and two-time all-star Lew Burdette (center) chats with Earl M. Accola (right) during a visit to the hospital in 1956.

In November 1957, the American Legion arranged a visit by New York Yankees legend Tony Kubek (right). In his career as a major-league shortstop, Milwaukee native Kubek made the All-Star team four times and was 1957 Rookie of the Year. The Braves and the Yankees met in the World Series in 1957 and 1958. The Braves captured the title in 1957, and the Yankees came back from a 3-1 deficit to clinch the series in 1958.

Prizefighter Jack Dempsey was not a native of Milwaukee, but he had a soft spot for the city, harking back to his 1918 victory over Bill Brennan at the Elite Roller Rink on West National Avenue. His winnings that night put money in his empty pockets. On a surprise visit in April 1950, Dempsey (left) clowns with director Delta C. Firmin before greeting patients.

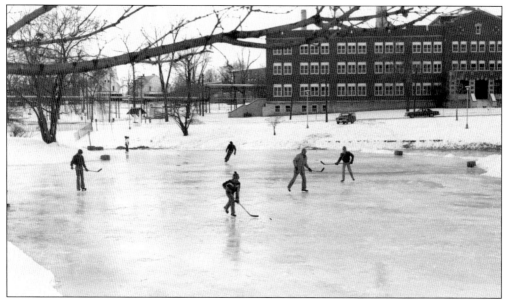
The frozen waters of Lake Wheeler provided the perfect surface for winter sports, including hockey. It was not uncommon for a group to set up a warming tent, light a bonfire, and serve hot chocolate. In the 1890s, one Civil War veteran nicknamed "Fancy Skater" was reported to have excelled on the ice. The hospital annex (Building 43) and some of the employee quarters are visible on the horizon.

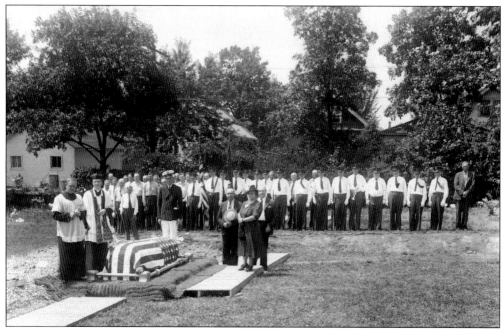
In the 1940s and 1950s, the cemetery was expanded southward along the western boundaries of the Home, moving closer to the adjoining neighborhood. In this funeral photograph, homes on South Oak Park Court are visible behind the tree line. In the foreground are, from left to right, Francis Rolfs (domiciliary member), Rev. Eustace Brennan (chapel custodian), ? Price (domiciliary officer), and three unidentified relatives of the deceased.

Seven
THE YEARS AFTER THE GREAT WAR

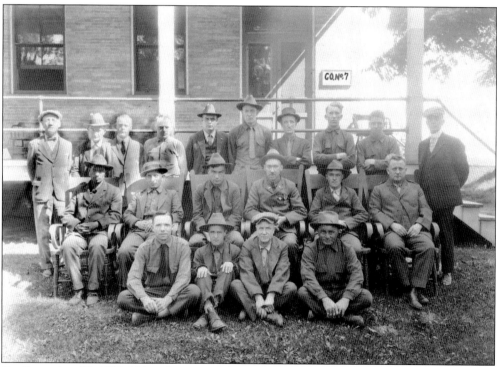

On December 29, 1916, Milwaukeeans read a startling headline: "Managers Vote to Abandon Institution Located Here." Jerome A. Watrous likened the move to closing a national landmark. Whether the idea was motivated by politics, economics, or concerns about villainous saloons, it did not matter in the end; the Great War and a new era of veterans had the last word. This photograph of World War I veterans was taken in 1920.

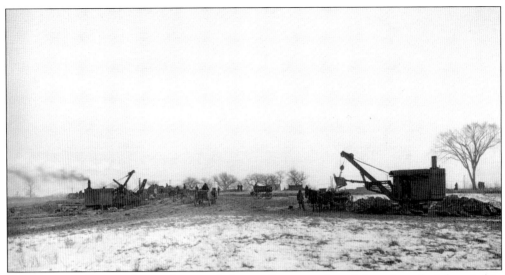

Horses were still in use during the initial phases of construction of the tuberculosis hospital in December 1921. Milwaukee was chosen as one of the locations for hospitals to accommodate the growing number of veterans suffering from this contagious disease after World War I. The southwestern section of the grounds, located at a distance from the Home population center, was chosen for maximum sun and ventilation.

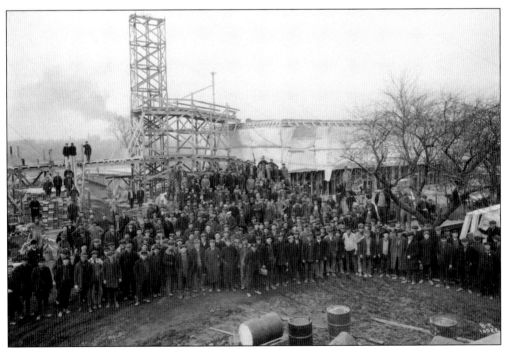

As anticipated during 1866 negotiations with the National Home's board of managers, the Northwestern Branch provided employment in dozens of trades and occupations for hundreds of Milwaukee residents. In this 1922 photograph, the employees of H. Schmitt & Son gather on the construction site of the future tuberculosis hospital.

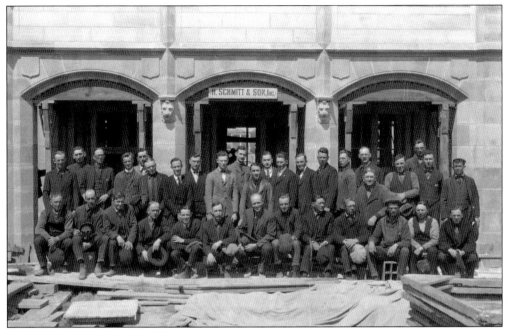

H. Schmitt & Son, which served as general contractor of the tuberculosis hospital, was owned by Herman Schmitt and his son Frank. In this 1922 photograph, foremen pose in front of the new administration wing. The Milwaukee architectural firm of Scott & Mayer also worked on the project under the supervision of architects Schenk & Williams of Dayton, Ohio.

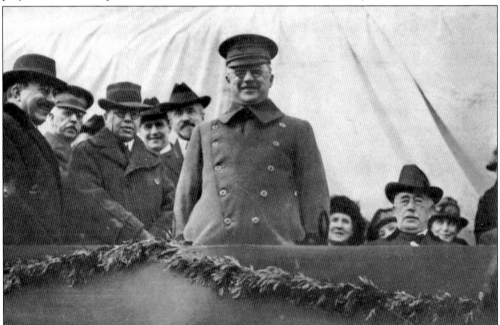

Veterans, dignitaries, staff members, and 5,000 ordinary citizens attended the cornerstone-laying ceremony for the tuberculosis hospital on February 22, 1922. Pictured on the speakers' platform are, from left to right, J.G. Kissinger, Col. Frank Kibbey, Phil A. Grau, Maj. James W. Wadsworth, Gen. George H. Wood, Maj. George E. Ballhorn, and Col. Jerome A. Watrous.

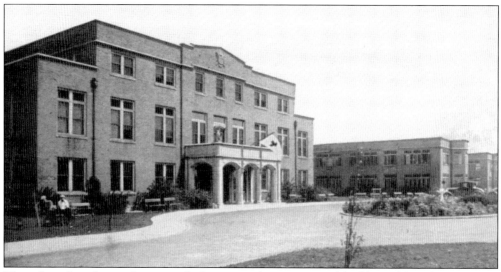

The tuberculosis hospital consisted of a group of six connected buildings (the administration building, the service building, and four infirmary buildings) and two freestanding buildings for ambulant patients. Fireproof construction techniques were used throughout the hospital's 101,713 square feet. The 1924 Home souvenir book brags that these are the "most modern and completely equipped hospital buildings of their kind in the world." An additional west wing, dedicated in 1938, served as a general hospital.

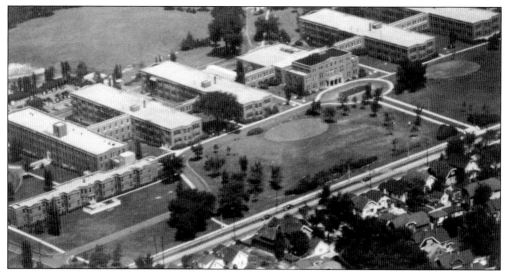

This aerial view shows the main tuberculosis hospital and one of the ambulant buildings (lower left). The hospital buildings were two stories high, with each floor containing a large washroom, baths, toilet, small dining room, kitchen, utility room, offices, wards with porches, and two solariums. Each patient had an inside room and a sleeping porch. The ambulant buildings were divided into small two-patient rooms with sleeping porches.

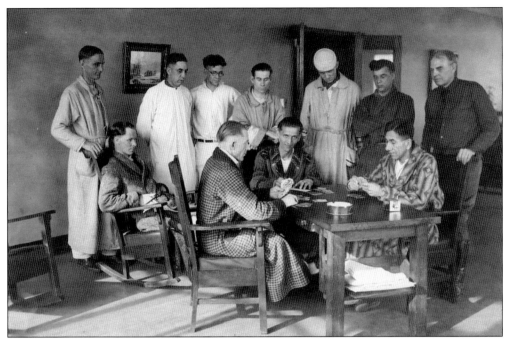

Patients play cards in one of the ward recreation rooms of the tuberculosis hospital. Recreation and amusement for patients included a 6,500-volume library and a 432-seat theater, which featured moving pictures and other theatrical amusements at least three times a week. Patients also enjoyed the pool and billiard room, which contained eight tables.

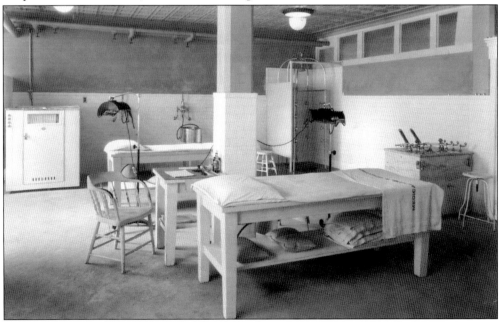

The hydrotherapy clinic pictured here represents some advances in physical medicine between World War I and World War II. The new tuberculosis hospital also included an eye, ear, nose, and throat clinic; surgical dressing room; electrotherapy clinic; and a genitourinary clinic. Photographs of these new areas are featured in the 1924 Home souvenir book.

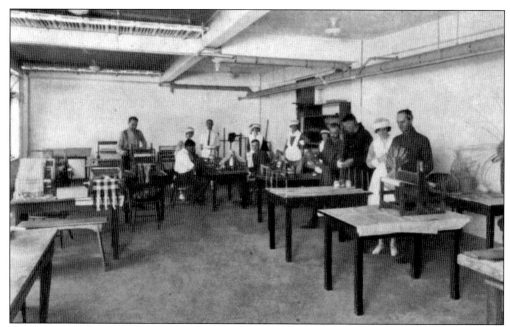

Occupational therapy aides in the tuberculosis hospital offered instruction in color and design work, leather craft, woodwork, academic and commercial subjects, agriculture, horticulture, and the science of raising poultry. The patient and aide at the far right are working at a tabletop loom. Larger looms were located in other buildings on the campus.

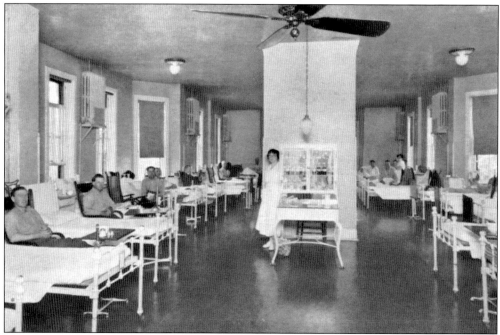

One of the Home's efficient nurses (center) supervises patients in the surgical convalescent ward. In addition to numerous minor operations, the hospital performed 629 major operations in 1923, boasting that 95 percent of patients were absolutely cured. The remaining five percent were primarily frail, elderly members who were not expected to recover.

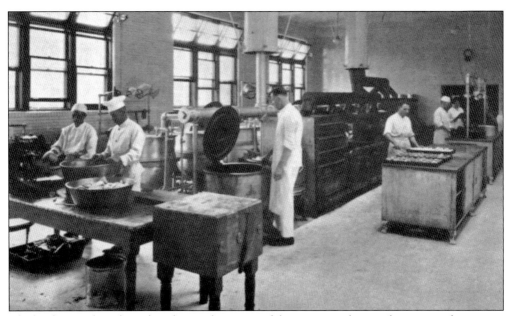

The kitchen in the tuberculosis hospital was part of the increasingly complex means of preparing and delivering nutritious meals to special-needs patients. At a time when the number of patients totaled 1,691 and staff members numbered 210, food purchases were astronomical. The kitchen and dining room were maintained according to strict sanitary guidelines.

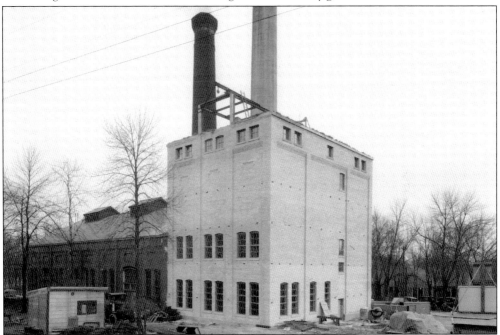

Heat, light, and hot water were furnished from a centrally located powerhouse. Seven boilers transmitted water to heat the buildings, while hot water for domestic purposes was produced by exhaust steam. The mains for the heating system were connected to buildings by tunnel or overhead lines. Photographed on December 1, 1933, this addition to the boiler house is viewed from the southwest.

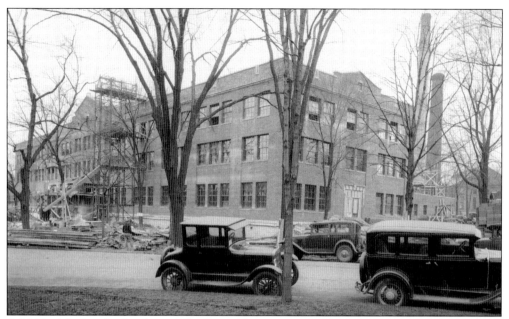

A 226-bed facility for the chronically ill is under construction in this photograph dated January 29, 1932. This was the only major building project at the Northwestern Branch in the 1930s, and one of the earliest buildings designed by the new Veterans Administration's Technical Services Division. In 1949, it was converted to a neuropsychiatric hospital; it was later used as a domiciliary building.

While the hospital annex was the only new construction on the grounds in the 1930s, several existing facilities were enlarged and updated, including the boiler house addition pictured here on December 1, 1933, and an addition to the storehouse. Buildings visible in the background of this photograph include, from left to right, a barracks, the main building, and the social hall.

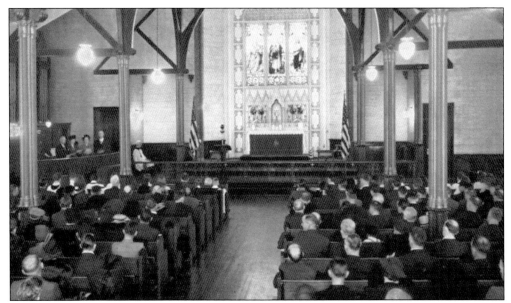

At this Sunday service conducted by Rev. Gustav Stearns (seated left of altar), the nave is packed with veterans and visitors. The professional choir and organist are on the far left. Not only did veterans benefit from the chaplain's ministry, but so did neighbors and friends. The expanded congregation turned to Stearns for weddings, baptisms, and confirmations, while also enjoying the yearly cycle of religious and patriotic holidays at the Home.

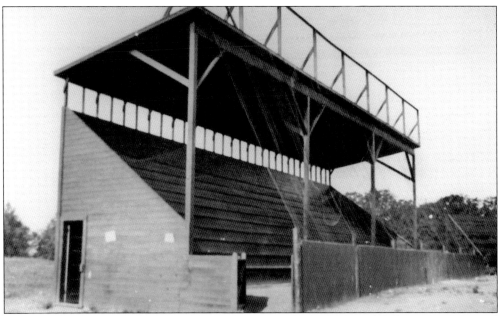

The 1924 Home souvenir book reported that the baseball grounds were filled every Saturday and Sunday. Amateur baseball leagues from Milwaukee and nearby cities gave regular exhibitions of "scientifically played" games. At community events, it was common to see visitors and veterans alike engaged in games of croquet and horseshoes. (Courtesy of West Milwaukee Historical Society.)

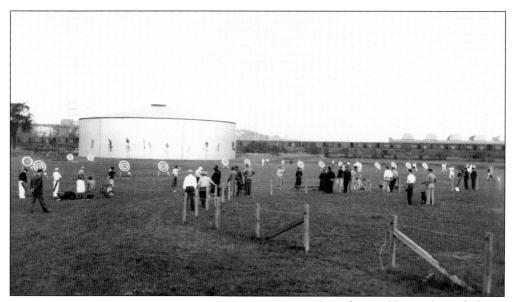

As early as 1875, members of what would become the National Rifle Association and other groups used the Home shooting range for practice and competition. The archery meet in the photograph was held on September 9, 1934. Several years later, members of the Wauwatosa Archery Club offered lessons for all domiciliary members and patients who were eligible and interested. (Courtesy of Milwaukee Public Library, Milwaukee Historic Photos Collection.)

These tennis players, posing on one of the Home courts, are, from left to right, Ross Ackerly and a Mr. Casthaus (both hospital staff), Charles Bell (guest), and Richard "Dick" Corbett (son of the Home treasurer). Richard's sister Elizabeth remembered that Gov. Cornelius Wheeler had the first tennis court laid out on grass, while her father had the first clay court.

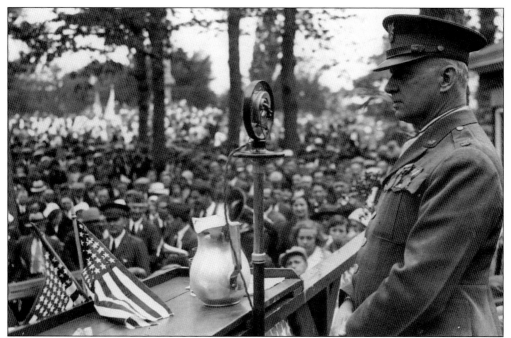

Col. Charles M. Pearsall, governor of the Home, pauses on the speakers' platform in Wood Cemetery on Memorial Day, around 1930. To his right is the cemetery round house. Constructed in 1900, the octagonal structure was used as a combined reception area and office. (Courtesy of Milwaukee County Historical Society.)

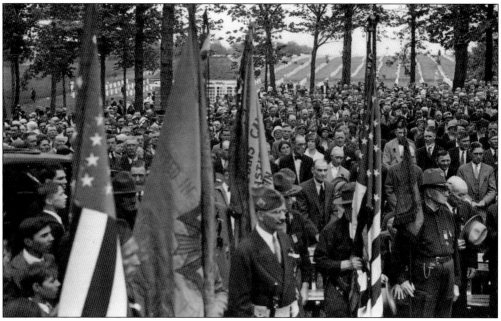

Color guards from the Home, the American Legion, and Veterans of Foreign Wars stand close to the speakers' platform while the crowd of Home members, patients, and ordinary citizens fills the green space reserved for public gatherings. Another cemetery structure is visible behind the flags. (Courtesy of Milwaukee County Historical Society.)

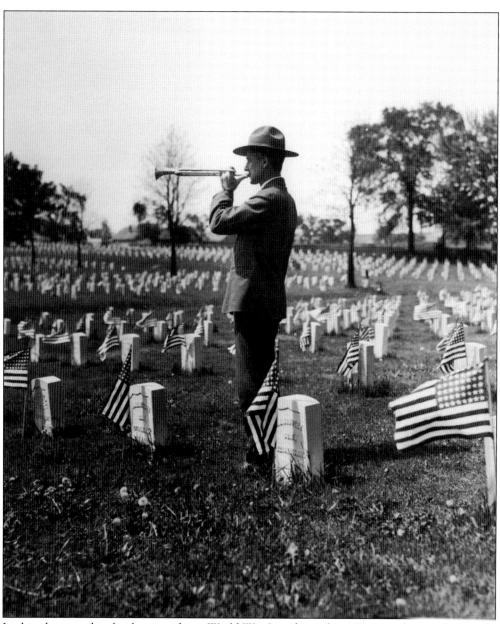

In this photograph, a bugler attired in a World War I uniform plays "Taps" at the conclusion of a 1930s Memorial Day commemoration. Small flags flutter in front of every grave. The cemetery, which holds the mortal remains of veterans from the War of 1812 to the present day, includes five Medal of Honor recipients, all from the Civil War. Throughout the cemetery are bronze plaques inscribed with verses from Theodore O'Hara's "Bivouac of the Dead." The plaques, given to the Northwestern Branch in the 1880s, were reset in stone mounts by the Work Projects Administration in 1941. A large plaque near sections four and seven is one of two markers on the grounds commemorating Pres. Abraham Lincoln's Gettysburg Address. In 1895, the first such plaque was placed at the Soldiers National Cemetery in Washington, DC. Beginning in 1909, the Army produced standard Gettysburg Address tablets for all national cemeteries. (Courtesy of Milwaukee County Historical Society.)

Eight
A NEW ERA OF VETERAN CARE

It is apparent in this November 1953 photograph that the original main building was still fully occupied. To meet the demand for services after World War II, additional facilities were built, including several Quonset huts for storage and maintenance. The veterans on the side porches in this photograph listen to one of the speakers at an American Legion Service Officers Conference.

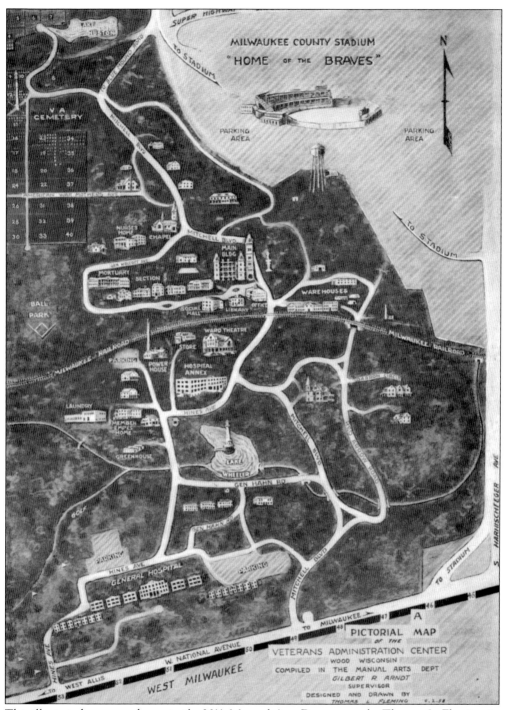

This illustrated map was drawn in the VA's Manual Arts Department by Thomas L. Fleming in September 1958. Among its notable features are Milwaukee County Stadium, the nurses' residence, the mortuary, the store, and the greenhouse, all of which have since been demolished. In 1962, Lake Huston (located at the upper left) was filled in to make way for a new interstate highway.

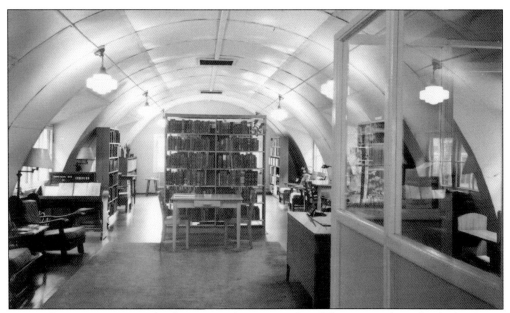

In an effort to improve medical services, the VA sought affiliations with medical schools, an arrangement made possible in 1946 by Public Law 79-293. In Milwaukee, a partnership with Marquette University School of Medicine and its successor, the Medical College of Wisconsin, flourished, advancing the causes of education, medical research, and improved medical practice. Above, the medical library was originally housed in one of the Quonset huts. Below, in April 1960, medical staff and residents met with internationally respected surgeon Dr. Robert Zollinger. Pictured are, from left to right, (seated) Zollinger and director Delta C. Firmin; (standing) Dr. ? Close, Dr. Francis C. Dickey, Dr. ? Ellison, and Dr. ? Smith.

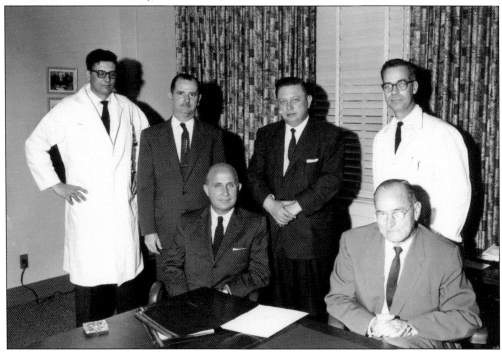

101

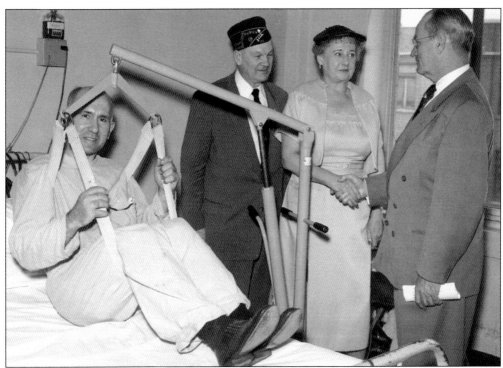

Mechanical devices used for repositioning and transferring those with limited mobility were critical for the safety of both patients and staff. Above, one such device, a mobile patient-lifter, was presented to the hospital on March 10, 1955. The unidentified patient is joined by, from left to right, an unidentified representative of the Cudworth American Legion Post, presenter Mona Weinberg, and director Delta C. Firmin. In the photograph below, representatives of the Mothers of World War II, South Milwaukee Unit, present a chair lift to Ward 4-N of the general hospital (Building 70) on December 21, 1953.

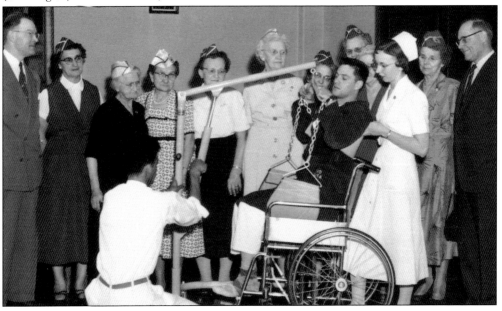

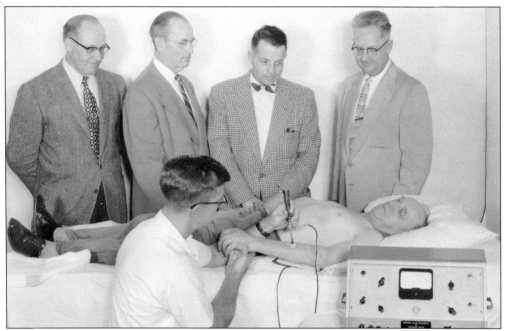

The needs of patients wounded in World War I and World War II led to advances in physical medicine and rehabilitation. The Schlitz American Legion Post presented this electrical stimulation machine in May 1956. Here, a technician demonstrates its use while director Delta C. Firmin (second from left) and other staff members observe.

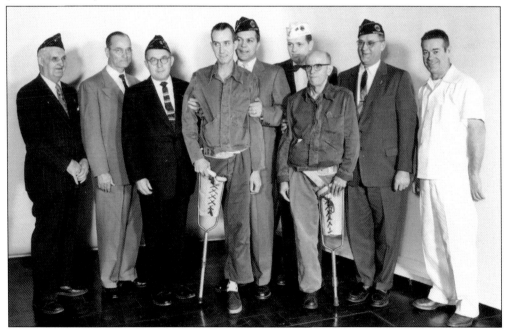

When Gen. Omar Bradley overhauled the VA after World War II, he created the Prosthetics and Sensory Aid Division, leading to advances in this critical discipline. In this photograph from February 1959, members of the Bell Telephone Company American Legion Post No. 427 present lightweight, temporary artificial limbs to amputees at the general hospital (Building 70).

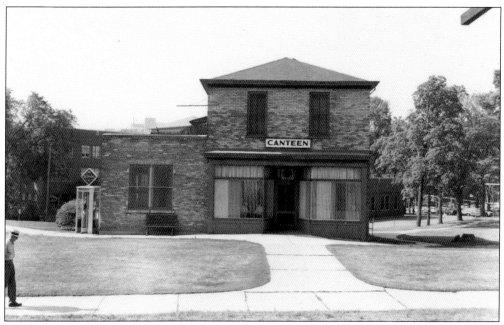

The canteen, pictured here in the 1940s, was located between the Ward Theater and the powerhouse, parallel to the railroad tracks just north of the hospital annex (Building 43). The elevated pipes that delivered steam from the boiler house to the buildings on the south section of the grounds can be seen at the right.

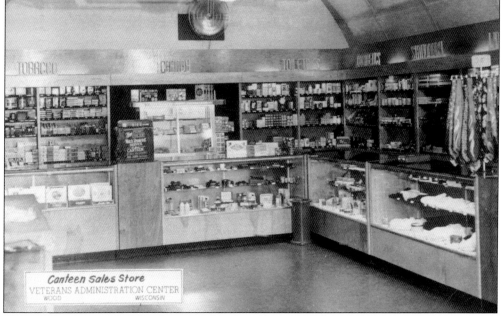

After receiving reports from veterans about problems with hospital concessions provided by contractors, Gen. Omar Bradley persuaded Congress to create the Canteen Service as a VA-run operation on August 8, 1946. The VA canteen in this 1950s photograph was located in one of the Quonset huts. Later, it was relocated to the basement of the main building; it now operates in the 1967 hospital (Building 111).

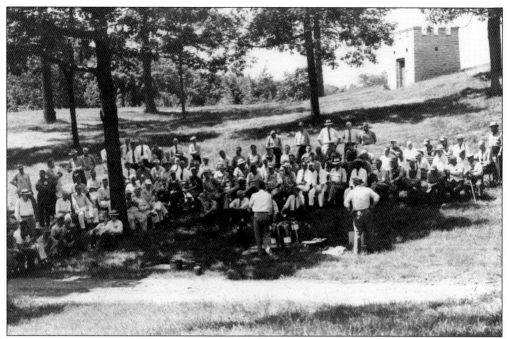

T.A. Lawrence, chief of safety and fire protection, gives a lecture and demonstration to Home members and staff on fire safety on July 27, 1950. The group is assembled in a shady area near the powder magazine (the small, castle-like structure at the upper right). The magazine, built in 1881, was used to store ammunition for the cannons on the artillery field and across from the main building.

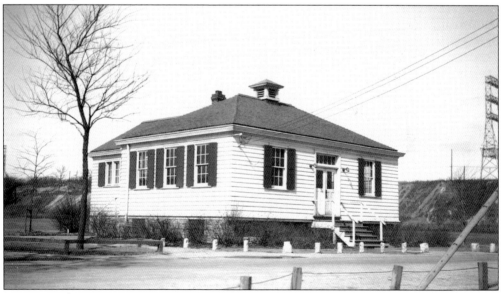

Recreational sports were an important component of rehabilitation and socialization. The field house in this photograph is a one-story clapboard structure, topped by small cupola for ventilation. Recreational activities included softball, tennis, horseshoes, and croquet. In 1946, a nine-hole pitch-and-putt golf course was added near the general hospital (Building 70). (Courtesy of Milwaukee Public Library, Milwaukee Historic Photos Collection.)

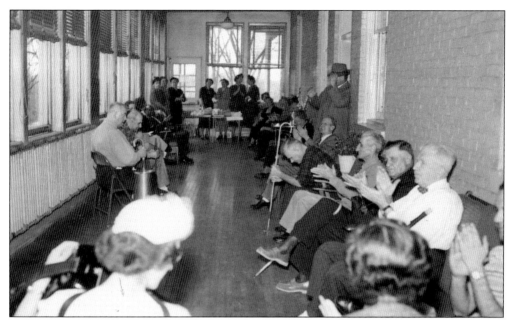

Early pioneers in rehabilitation of the visually impaired emphasized assistive techniques, new teaching methods, and, most important for blind veterans, a sense of self-worth and confidence. Those principles were adopted nationwide. In this upper photograph, members of the talking book group gather for a party on April 8, 1953, in the domiciliary solarium for blind residents. Below, members of the competitive bowling team use lightweight guide rails, positioned in the gutter and held in place with a bowling ball, to help determine the position and angle of each shot. Members of the Disabled American Veterans assist the bowlers in this competition, which included Charles Theis (fourth from left).

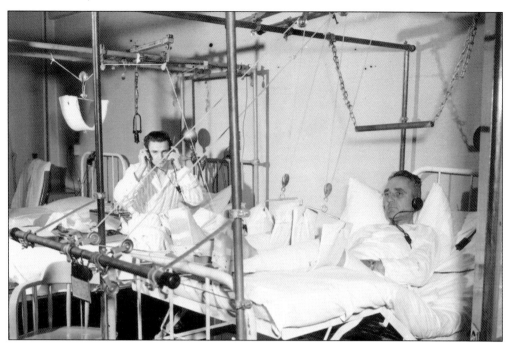

World War I put a temporary halt to ham, or amateur, radio operation, but the hobby resumed with a burst of enthusiasm after the war. Pictured above, around 1930, two patient operators tune in from their hospital beds. In the 1963 photograph below, director Delta C. Furmin (center) and chief of staff Dr. Frederick J. Rachinle observe patient Dale Engler's use of prism glasses, designed for reading while prone in bed. Engler, who had been confined to an iron lung after contracting polio, blossomed in his newfound vocation as a writer, winning the 1961–1962 Hospitalized Veteran Writing Program award. In some accounts, he said that writing saved his life. Engler was also a ham radio operator.

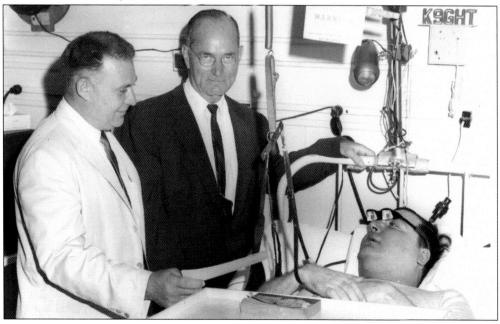

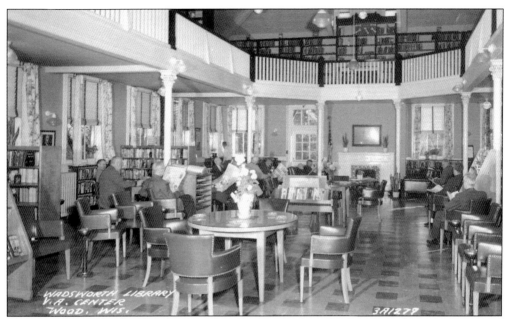

Above, the Wadsworth Library was redecorated and refurnished in 1949 through a generous donation from Dorothea Sauer in memory of her son Reuben, who died shortly after his return from service in World War I. The upgrades included leather-covered chairs, light birch furnishings, a new rubber-tile floor, and drapes. For patients who were confined to the general hospital (Building 70), an additional library, pictured below, was located near the hospital theater. New books in both facilities were reviewed in the *Wood Tattler*, the regular publication produced by patients and staff beginning in 1946. Reading continued to top of the list of veteran hobbies.

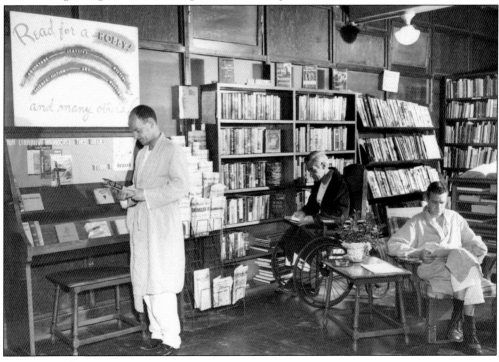

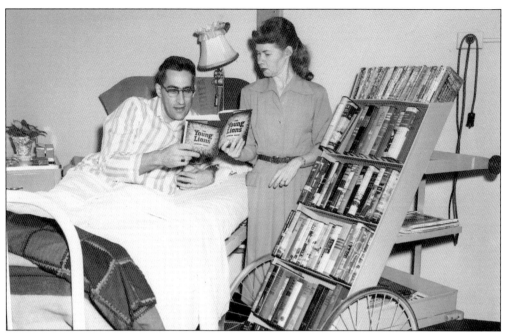

Above, staff librarian Laura Bergeron delivers books to a general hospital patient, around 1952. Thanks to library staff and volunteers, the book cart made regular rounds to patient wards, sunrooms, and visitor areas. It was designed to display a wide array of books on the front and to carry magazines and newspapers on the flat shelves on the back. Below, the Wadsworth Library lifted its rules on loud conversation for parties and hobby days; and at the October 1951 hobby day, Art Marsen (on trumpet and sax) conducted the recreational music group. He also directed a volunteer orchestra composed of patients and staff for productions at the Ward Theater.

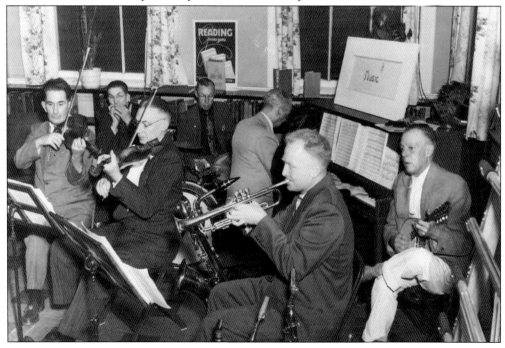

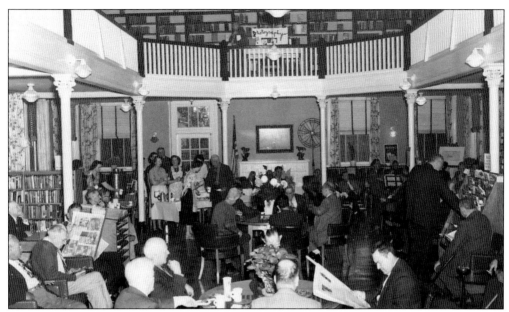

Above, the Wadsworth Library is packed for the October 1951 hobby day—thanks, in part, to refreshments served by library volunteers. The Gray Ladies of the West Bend Chapter of the American Red Cross had a long tradition of service to the library. One veteran mans an exhibit on photography on the mezzanine, while the band demonstrates the joy of music. Below, a patient tries his hand at a hand-cranked knitting machine, donated in April 1949 by a veterans post from Ripon. The gentleman directly behind the patient holds a completed project that appears to be a small slipper.

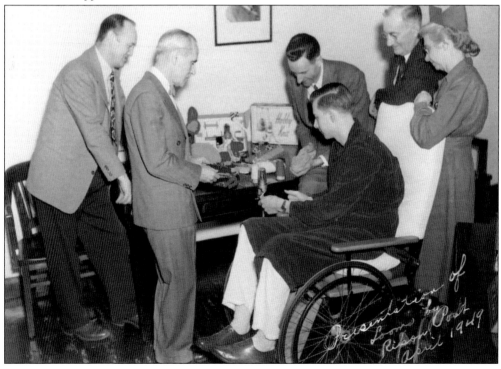

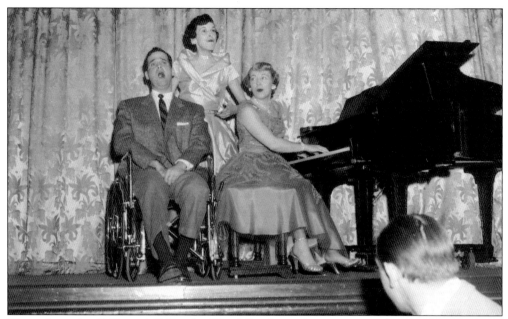

Throughout the 1950s and 1960s, the Wood Employee Association produced musicals, variety shows, and serious dramas at the Ward Theater and in the hospital theater for the entertainment of patients and staff. Their first venture, under the name of the Wood Termites, was the 1954 *Follies*. Above, one of the musical numbers was "Love in the Woods," performed by Vito Diciaula (left) and Lu Ann Wendell (center), with Harriet Werra on piano. Below, these cancan dancers' high kicks would be mimicked by an all-male ensemble later in the program. The evening included square dances, choral pieces, and comedy routines.

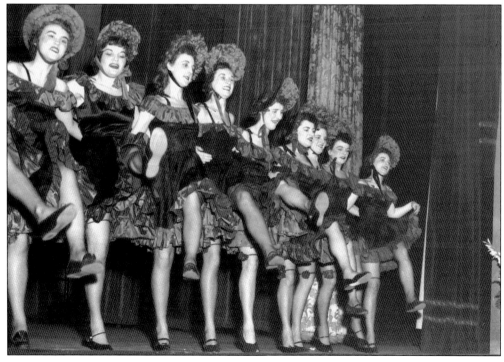

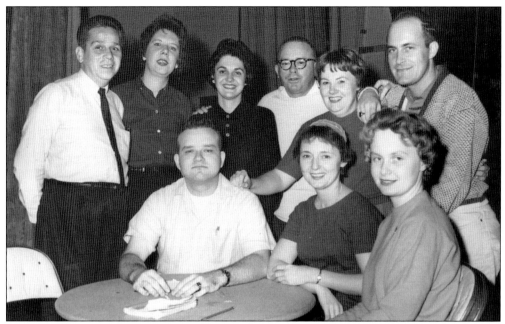

In the photograph above, members of the Wood Players gather for a photograph with director Thomas Zinos (standing, far left) and managing director Dr. Cecil H. Mahaffey (standing, fourth from left). Zinos was an administrative assistant in the domiciliary division, and Mahaffey was a staff physician in neurology. The players hailed from several departments on the campus, including art therapy, medical transcription, laboratory, educational therapy, and nursing. Pictured below in March 1960, the Wood Players presented the "Ring-Ting-a-Ling Circus." The VA Band, conducted by Art Marsen, accompanied the antics of clowns, calypso circus, and cha-cha dancers. Sara McDuffie reigned as circus queen.

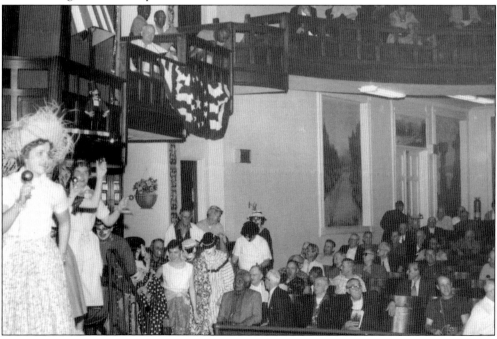

Productions featuring this unidentified (but convincing) Abraham Lincoln may have contributed to the persistent myth that the Ward Theater was an exact replica of the Ford Theater in Washington, DC, the location of Lincoln's assassination. A 1969 letter from the National Trust for Historic Preservation refutes that claim.

Below, on March 16, 1961, members of the Wood Employees Association portrayed injured victims for a disaster drill at the general hospital (Building 70). Medical staff who experienced this kind of training for the first time said the makeup and realistic portrayal of the cast helped them understand the seriousness of disaster planning.

The Bertha Kesselring Memorial Nursery (above) was dedicated on November 9, 1952, to care for children of visitors and hospitalized veterans. Kesselring, a longtime volunteer and member of the Veterans of Foreign Wars Auxiliary, suggested the idea shortly before her death. The nursery was located in one of the Quonset huts and was supervised by Red Cross Gray Ladies and Junior Red Cross members.

VA employees organized a food drive for families of disabled veterans during Christmas 1936. Here, a Christmas tree in the dining hall of the main building is surrounded by baskets filled with turkeys, Liberty coffee, Jack Frost sugar, Yankee rye, fresh fruit, vegetables, and nuts. This kind of outreach shows how well employees understood their work as a form of service to those who sacrificed for their country.

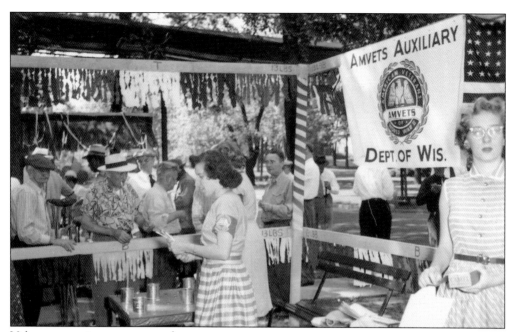

Voluntary service groups staged summer carnivals to entertain domiciliary members and hospitalized veterans. In addition to the American Veterans (AMVETS) Auxiliary (pictured), supporting groups included Navy Mothers of America, American Legion, Women's Relief Corps, Blue Star Mothers, Veterans of Foreign Wars, Disabled American Veterans, American Red Cross, Mothers of World War II, Marine Corps League, Military Order of the Purple Heart, Jewish War Veterans, and the Army & Navy Union.

Grace Kissinger of the West Bend Chapter of the American Red Cross and her service dog are the center of attention at this October 1965 party in the Wadsworth Library. Kissinger, a regular library volunteer, often entertained visitors by playing her accordion. In this photograph, her faithful friend sports a miniature Red Cross cap.

VA administrators relied heavily on financial and material support from veterans' service organizations, auxiliaries, patriotic groups, and community organizations. Above, officials and local members of the United Spanish War Veterans Auxiliary pause outside one of the domiciliary buildings before visiting with members of Company 3 on March 18, 1955. Below, assistant director Earl M. Accola (third from left) listens to a demonstration of an RCA Victor reel-to-reel tape recorder donated by a local chapter of Sigma Alpha Iota, the national professional music fraternity. One of its members (far right) delivered the gift on February 21, 1956.

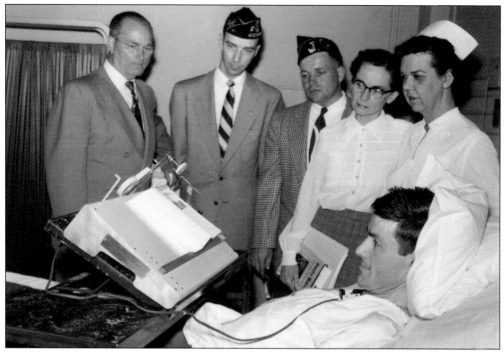

Local veterans' service organizations made sure patients had the latest assistive devices. On May 18, 1954, members of American Legion Schlitz Post No. 411 donated an automatic page turner. This device enabled Navy veteran Arthur Koch (in bed) and others with limited use of their upper limbs to use an electric switch or pneumatic device to view printed materials. The post was represented by service officer Norbert Edwardsen (third from left).

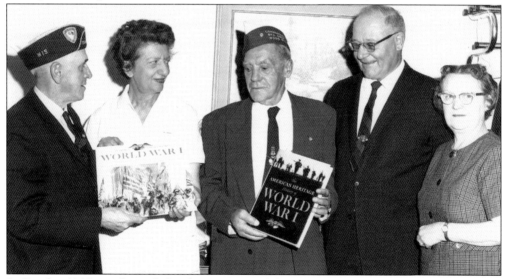

In October 1964, members of a local post presented the *American Heritage History of World War I* and a recording made by veterans of World War I to the patient libraries. Pictured here are, from left to right, John Kocian (post commander), Florence Markus (chief librarian), John Smith (VA volunteer and commander of the World War I post at the Home), unidentified, and Lorraine Klatt (representative of the World War I Auxiliary).

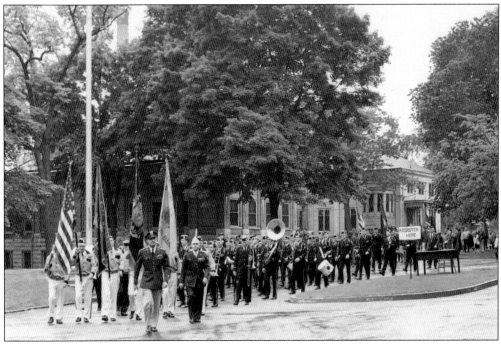

On Memorial Day 1952, a procession marches east along Wolcott Avenue and around the main building toward the cemetery. Veterans and ordinary citizens watch from the steps of the Wadsworth Library (left) and the social hall (right). This area in the heart of the historic district featured a massive flagpole on an elevated platform.

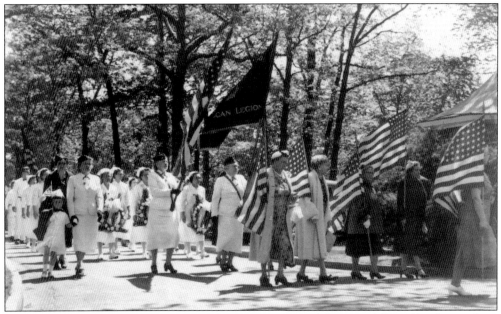

Members of the American Legion Auxiliary, bearing national flags, are followed by the auxiliary color guard and VA nurses carrying wreaths as they process along Juneau Avenue toward the speakers' platform on Memorial Day, around 1950. A young girl (left) is dressed in a traditional nurse's uniform, cap, and cape.

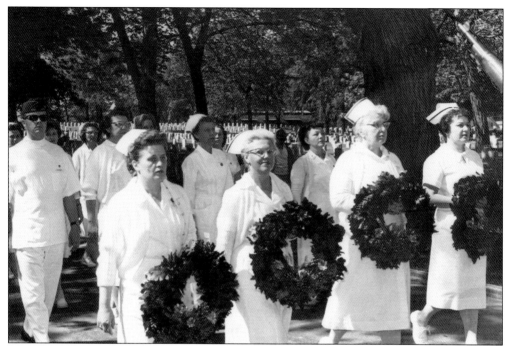

VA nurses carry wreaths as they march through Wood Cemetery on Memorial Day, around 1960. According to Memorial Day programs from 1956 and 1965, the nursing staff placed all the memorial wreaths while the Blatz American Legion Post band, directed by Everett Kissinger, played "Ave Maria." The program also included a recitation of Pres. Abraham Lincoln's Gettysburg Address.

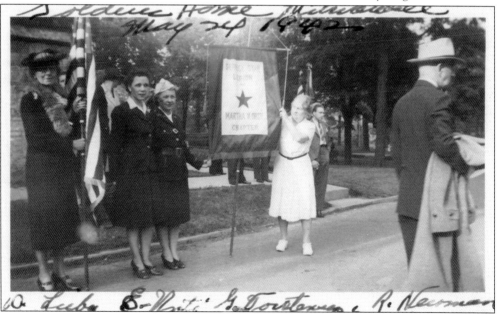

On or before each Memorial Day, patriotic organizations gathered for the Massing of the Colors, a salute to the dead instituted by Rev. Gustav Stearns. This photograph features the Martha M. Orth chapter of the Service Star Legion, including, from left to right, Dorothy Lieber (color-bearer) Eleanor M. Arte (president), Grace ? (vice president) and Rose Newman (banner carrier).

Above, participants and spectators assemble near the music stand for the Massing of the Colors. On several occasions, the international flags collected by Rev. Gustav Stearns were added to the national and post flags used in this ceremony. Below, during the annual Water Ceremony, an unidentified gentleman casts a memorial wreath into Lake Wheeler in memory of soldiers and sailors lost at sea. Earlier in the 20th century, the ceremony was held aboard a steamer in Lake Michigan, several miles from Milwaukee. In time, the two ceremonies were merged and later added to the annual Memorial Day program. The decorative lighthouse in front of the speaker's platform is mentioned in descriptions of the grounds as early as the late 1890s.

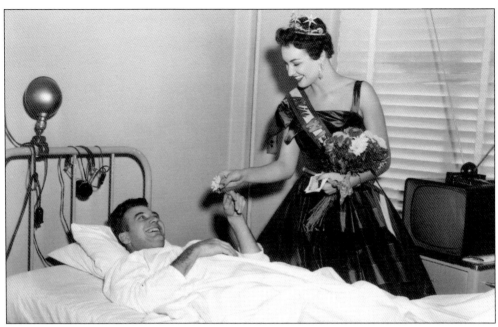

Above, Miss Wisconsin 1956, Lynn Holden of Milwaukee, hands a flower to a patient during her visit to the general hospital (Building 70). Holden was a junior at Ripon College before her reign and was named best musician at the Miss America Pageant. Below, Miss Wisconsin 1958, Kay Joan Ross of West Allis, appears with director Delta C. Firmin (left) and a representative of the Disabled American Veterans during her coronation as Forget-Me-Not Queen (the kickoff for a fundraising campaign involving the sale of artificial forget-me-nots) on September 22, 1958. Ross was a student at Layton School of Art and Marquette University. For many years, the reigning Miss Wisconsin has visited hospitalized veterans at Wood on Veterans Day under the auspices of the American Legion.

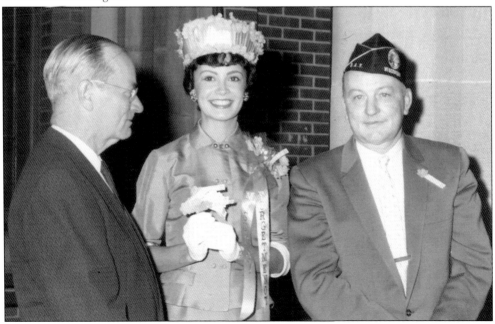

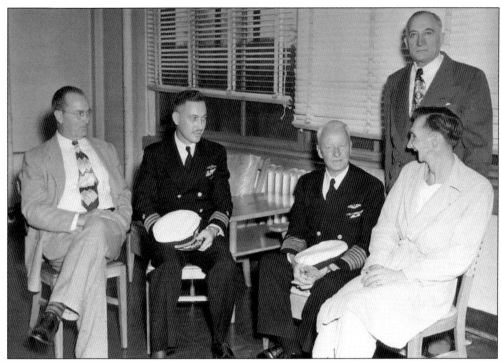

An unidentified patient is delighted at the visit of Adm. Chester W. Nimitz (third from left). Also pictured are Delta C. Firmin (far left), an unidentified officer, and Dr. Lieberman (standing). Presidents, military heroes, and other notables visited the Milwaukee VA over the years, including Gen. Omar Bradley in 1946, during his tenure as head of the Veterans Administration.

After Elizabeth Corbett moved to Greenwich Village in New York City to pursue a career in writing, she carried on a regular correspondence with VA staff. When she returned to Milwaukee in 1954, Corbett toured her childhood stomping grounds, which had been transformed by decades of construction. This photograph features, from left to right, Florence Markus, Delta C. Firmin, Earl M. Accola, and Corbett.

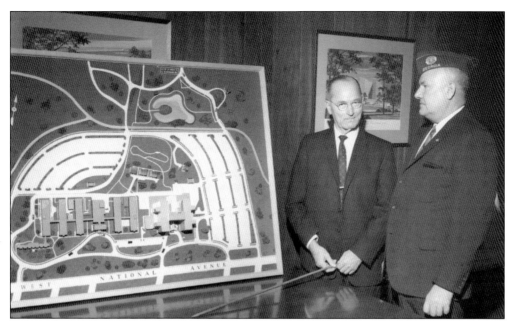

With work well underway for a new medical center, director Delta C. Firmin (left) was proud to explain architectural plans to national commander of the American Legion, James E. Power of Georgia. Legion officials were visiting Wood VA in connection with Regional Rehab Conference of American Legion Auxiliary in January 1963.

US congressman Clement J. Zablocki (left) and Whitley Ashbridge, the VA's assistant administrator for construction, display the trowel used in laying the cornerstone for the new medical center in March 1963. In 1983, following the death of Congressman Zablocki, Pres. Ronald Reagan signed Public Law 98-528, changing the name of the complex to Clement J. Zablocki Veterans Administration Medical Center at Milwaukee, Wisconsin.

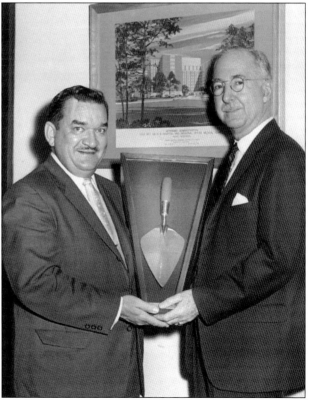

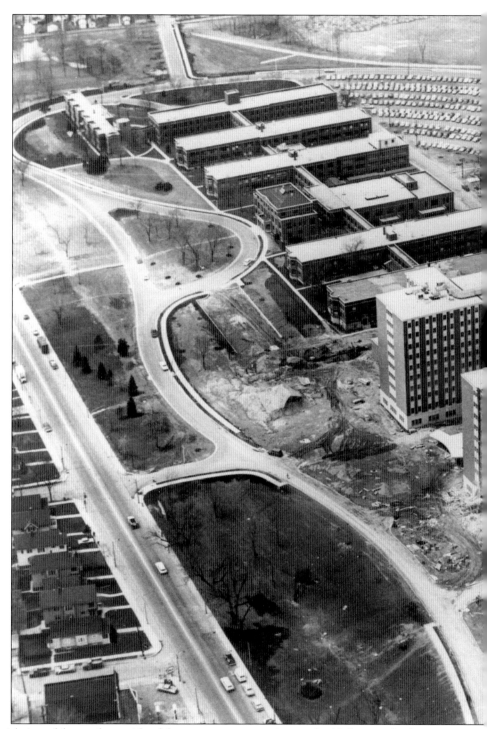

In this aerial view of the southeast side of the campus, construction on the 10-floor medical center (Building 111) is still in progress. The wings of the general hospital (Building 70) are connected to the new building by a narrow corridor. One of the ambulant buildings is still standing, and the footprint for the other is visible at center left. When the medical center was dedicated on May 15,

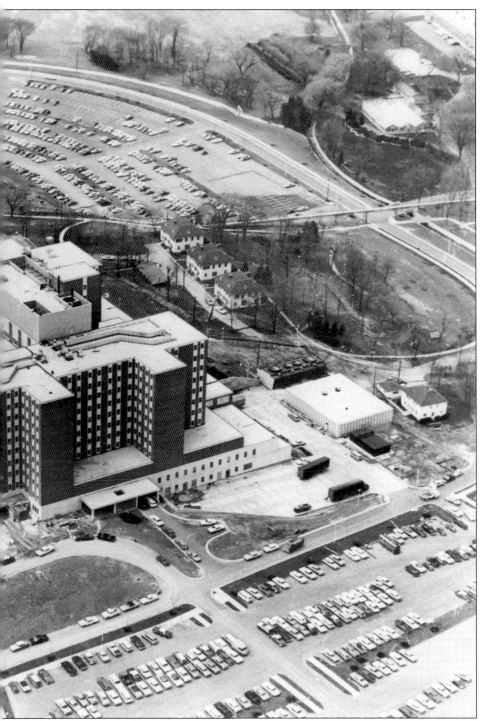

1966, Building 70 was repurposed for education and research. The campus serves patients from Wisconsin, Illinois, and Michigan, and veterans needing specialized treatment, such as those with spinal cord injury, may travel to Milwaukee from locations across the country.

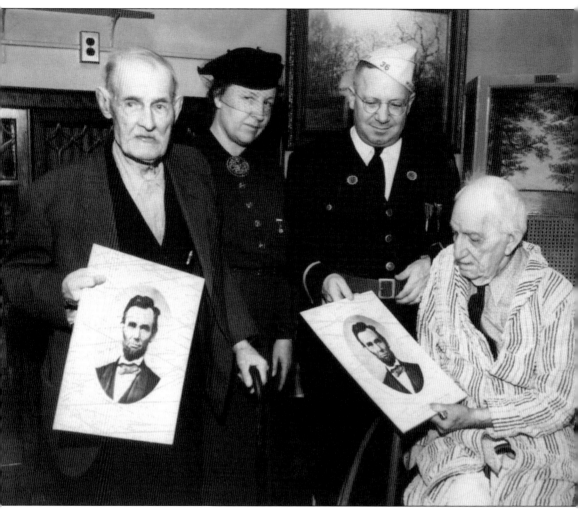

In his 1881 *History of Milwaukee*, Frank Flowers muses about the passing of Civil War veterans at the Home: "Here a grateful people come to read in living letters the story of the last great fight for liberty, and learn its value at the price it cost. And when . . . the cemetery shall have folded to its motherly breast the last tired survivor, and closed the book . . . let future generations, as they visit this hallowed spot, keep ever green in memory the history it contains." In this 1938 photograph, representatives of the American Legion present two unidentified Civil War veterans with commemorative prints of Pres. Abraham Lincoln. As each generation of veterans passes into memory, the Zablocki VA campus and its iconic Old Main building continue to serve as enduring symbols of the nation's promise to its veterans—a powerful reminder of a great and lasting legacy. (Courtesy of Wisconsin Historical Society, WHS-75431.)

Bibliography

Corbett, Elizabeth. *Out at the Soldiers' Home: A Memory Book*. Milwaukee: West Side Soldiers Aid Society, 2008.

Flowers, Frank. *History of Milwaukee*. Chicago: Western Historical Society, 1881.

Julin, Suzanne. *National Home for Disabled Volunteer Soldiers: Assessment of Significance and National Historic Landmark Recommendation*. Washington, DC: National Park Service, 2007.

Kelly, Patrick J. *Creating a National Home: Building the Veterans' Welfare State, 1860–1890*. Cambridge, MA: Harvard University Press, 1997.

Marten, James. "A Place of Great Beauty, Improved by Man: The Soldiers' Home and Victorian Milwaukee." *Milwaukee History*, Spring (1999): 2–15.

Plante, Trevor K. "The National Home for Disabled Volunteer Soldiers." *Prologue*, Spring (2004): 56–61.

Staff, Andrew. *Milwaukee's National Home for Disabled Volunteer Soldiers: Creation and Early History*. Milwaukee: Friends of Reclaiming Our Heritage, 2012.

www.historicmilwaukeeva.org.

Discover Thousands of Local History Books
Featuring Millions of Vintage Images

Arcadia Publishing, the leading local history publisher in the United States, is committed to making history accessible and meaningful through publishing books that celebrate and preserve the heritage of America's people and places.

Find more books like this at
www.arcadiapublishing.com

Search for your hometown history, your old stomping grounds, and even your favorite sports team.

Consistent with our mission to preserve history on a local level, this book was printed in South Carolina on American-made paper and manufactured entirely in the United States. Products carrying the accredited Forest Stewardship Council (FSC) label are printed on 100 percent FSC-certified paper.